Lená Taku Wasté

These Good Things

Selections from
The Elizabeth Cole Butler Collection
Of Native American Art

Bill Mercer

PORTLAND ART MUSEUM
PORTLAND, OREGON

Acknowledgments

Mounting an exhibition and producing a catalogue requires the efforts and talents of numerous individuals. The Portland Art Museum is grateful first to Bill Mercer, the Museum's curator of Native American art, for his deep devotion to the presentation and interpretation of Native American art, and for his efforts in bringing this exhibition and catalogue to fruition. In addition, the Museum wishes to acknowledge the contributions of assistant director Linda Brady Johnson; exhibition designer David Potter and his staff; registrars Marc Pence, Ann Eichelberg, and Adrienne Sturbois; conservators Sonja Sopher and Elizabeth Chambers; curatorial assistant Sarah Schleuning; and development director Lucy Buchanan for their efforts on behalf of this project. Two students, Marcia de Chadenedes and Genevieve Scholl, volunteered their time to assist Mr. Mercer and made valuable contributions.

Production Notes

This catalogue has been designed and produced by John Laursen at Press-22. The text was edited by Nadine Fiedler. The transparencies were created by Bill Bachhuber, except for those on pages 22, 42, and 100, which were created by Guy Orcutt. The 175-line color separations were laser-scanned by George Woolston at Color Technology. The printing was done by Millcross Litho on acid-free 80# Lustro Dull book paper. The books were smythe-sewn and bound by Lincoln and Allen.

ISBN 1-883124-05-0

Sponsors

ELIZABETH COLE BUTLER

Foreword

It is with great pride that the Portland Art Museum publishes this catalogue in conjunction with the exhibition *Lená Taku Wasté (These Good Things): Selections from the Elizabeth Cole Butler Collection of Native American Art*. The Board of Trustees and I are particularly enthusiastic, as this exhibition and book mark the first time since Mrs. Butler donated the collection to the Portland Art Museum that her objects have been presented comprehensively. *Lená Taku Wasté* is an appropriate title, for it embraces the aesthetic and functional qualities of the objects chosen for inclusion here and also suggests the ongoing theme of Mrs. Butler's years of acquiring Native American art.

Mrs. Butler is of Choctaw heritage and, according to Southeastern Woodlands Indian tradition, women leaders such as Mrs. Butler are particularly revered. It was often the "beloved woman" who provided determined leadership in times of crisis or change. In this regard, Mrs. Butler personifies her heritage. She began collecting Native American materials in 1970 with the purchase of some basketry; in fact, her collecting began in earnest at an Indian art show in Portland, where she acquired a large body of baskets. Her interest grew to collecting other types of objects that illustrate the art and culture of tribes across North America. Her criteria for purchase are simple, but profound: each object must be visually exciting, and each object must stand up aesthetically far beyond its utility. In short, each acquisition lives up to "These Good Things."

In 1974 Mrs. Butler opened her own private museum in Eugene, Oregon. From then until 1982, she curated exhibitions out of her growing collection. These exhibitions reflected her intelligent and insightful method of collecting, with objects organized according to geographic origin and arranged to highlight both the beauty and the service of each piece.

It is a fundamental truth that great art museums are the products of great collectors. Thus, we were extremely fortunate when, in 1987, Mrs. Butler entrusted her exceptional collection to the Portland Art Museum. To date, the Elizabeth Cole Butler Collection of Native American Art consists of over two thousand objects; indeed, the works represented in *Lená Taku Wasté* are barely the tip of the iceberg in terms of the treasures made available by Mrs. Butler for public enjoyment. Mrs. Butler's generosity, and her continuing practice of donating works of art, make her one of the Portland Art Museum's single most generous living benefactors. We are deeply grateful to her.

JOHN E. BUCHANAN, JR.
Executive Director
Portland Art Museum

Introduction

There is no single word for "art" in the many Native American languages. The lack of a single term that can be translated as "art" in English, however, does not indicate a lack of creativity or aesthetic sense on the part of Native Americans. Indeed, the creative process is traditionally a constant presence: every action, thought, and deed is considered to be a creative and aesthetic expression that is a natural part of daily life.

Native American material culture reflects this seamless integration of creativity and aesthetics. Objects are traditionally appreciated for both their functional abilities and their aesthetic qualities, with appreciation weighted equally toward both aspects: an object cannot be totally appreciated if it is not functional nor can it be completely admired if it is not considered to be beautiful. Because of this dual nature inherent in Native American objects—utilitarian and aesthetic—it is not surprising that "art" is not a part of Native American vocabularies. Instead, phrases such as *lená taku wasté* (Lakota for "these good things") are often used. A phrase like this simply and elegantly accepts both the utilitarian and aesthetic elements as the natural and appropriate way *things* should be.

Most Native American objects were traditionally utilitarian, and it was imperative that they work well for their specific purpose. For example, the traditional use for an Acoma pottery jar was as a water container; it needed to be watertight; it needed to have a high shoulder, so that it would be easy to carry; and it needed to have a constricted neck, to reduce evaporation. Although few of these jars are presently used to store water, Acoma potters continue to place an emphasis on the functional nature of their creations. As Mary Lewis Garcia has remarked, "My potteries can even be used in the microwave."

As the traditional use of many Native American objects has decreased, a different function—as marketable items—has increased. Collectors, gallery owners, scholars, and museums have created a demand for Native American objects as commodities. This economic function has become part of the overall aesthetic and is now just as important as any other aspect. Economics often motivates an individual to produce items and is a significant influence on what types of objects are created and how they are made. A Pomo basket maker, for example, might specialize in feathered gift baskets because of the belief that collectors will pay more for them than they would for twined storage baskets.

Since each of the many hundreds of Native American cultural groups has its own unique world view, each group has its own traditional concept of what makes an object aesthetically pleasing or "good" beyond its functionality.

The characteristics that are used to determine the merits of any given object, however, are common to many different Native American groups. These physical characteristics include the materials and techniques used to create an object, its shape as a reflection of its intended function, and its decoration.

Objects are made from materials that fulfill the requirements for their intended use and that are readily available from the local environment or are otherwise easily procured. The techniques used to produce objects from the correct materials have been established by generations of individuals within each tribal group who, by trial and error, have developed the appropriate methods to create specific types of objects. Western Apache basket makers, for example, coil their basketry bowls and jars but twine their burden baskets. While it would be possible to twine a bowl, such an action would be recognized as inappropriate and the resulting basket considered to be unusual according to tradition.

Tradition, as it relates to the creation of objects made and used by Native Americans, is quite significant. The process of creating an object using the traditional materials and methods is considered to be that object's most important aspect, solidifying relationships between members of each tribal group and establishing a connection between individuals and their ancestors who developed the traditions. Objects therefore are not just the product of a single person but embody the continuation of generations of creativity.

Although traditional processes are very important in Native American aesthetics, they do not stifle creativity. Originality within established norms is encouraged, while repetition and direct copying of decorative elements is considered inappropriate. Most flat cornhusk bags, for example, are approximately the same shape, yet each is decorated with a design that is different from those on any of the thousands of other cornhusk bags.

Native American artists traditionally experimented with new materials in an effort to develop objects that would be better suited for their intended use as well as to find quicker and easier methods of construction. Many of the objects that today are recognized as being "traditional" may, in fact, be the result of materials that were introduced by non-Native people and adapted by Native Americans for their own use. Glass beads and manufactured cloth are excellent examples of how introduced materials were transformed. Specifically, button blankets, now worn throughout the Northwest Coast on important occasions, are created entirely of materials, wool cloth and mother-of-pearl buttons, that were introduced by Europeans.

Decorative elements are the most visually striking aspects of any Native American object. In many instances the designs complement the object's shape. Traditionally, it was imperative to be able to recognize objects and people with-

in the same tribal group, and thus certain decorative elements became established tribal or family traditions, affording a sense of security and solidifying personal and tribal relations. Many Northwest Coast objects, for instance, are representational and refer to specific clan and family histories.

Lená Taku Wasté acknowledges the dual nature of Native American objects as both functional and beautiful things. The objects selected for the exhibition and illustrated in this publication are all from the Elizabeth Cole Butler Collection of Native American Art. This renowned collection includes prehistoric, historic, and contemporary works from throughout Native North America. Although Mrs. Butler focused primarily on baskets when she began collecting in 1970, the scope of her collection soon expanded. It now embraces a wide range of objects, both practical and beautiful, that illustrate the tremendous diversity of Native American material culture and offer an accurate reflection of Native American ideals. Numbering over two thousand pieces, this collection continues to grow, thanks to Mrs. Butler's vision and to her desire to share her appreciation of Native American art and culture with the public.

Both exhibition and catalogue were developed to provide a representative survey of the Butler Collection. Though selecting from such an extensive and diverse collection involves making difficult choices, it is also quite pleasurable, and we are proud to present the hundred and fifty works illustrated here. They are organized into six groupings that correspond to some of the cultural and geographical regions of North America: Northwest Coast, including the Aleutians; Plateau; California, including some of the peoples of the Great Basin; Southwest; Plains; and Woodlands, which includes the Northeast, Southeast, and Great Lakes areas. Within each regional section objects are arranged by type to aid the viewer in observing similarities and differences between tribal styles.

The text of this catalogue uses the present tense when describing many Native American traditions. Although all of the objects presented here are historical, the traditions that led to their creation are very much alive and still in practice. We hope that this approach will encourage readers, while appreciating these objects of the past, to recognize that the aesthetic principles embodied in *lená taku wasté* continue to be a vital part of Native American life.

BILL MERCER
Curator of Native American Art
Portland Art Museum

Tlingit

Tshimshian

Bella Bella

Bella Coola

NORTHWEST COAST

Kwagiutl

Plains Cree

Blackfeet Assiniboine

Salish

Nuu-Chah-Nulth

Mand

Klickitat Nez Perce
Twana Cayuse
Wishxam PLATEAU
Umatilla Crow
Wasco Lakota

Klamath

PLAINS

Karok
Yurok
Hupa

CALIFORNIA

Maidu
Pomo
Washoe

Cheyenn

SOUTHWEST

Yokuts Paiute
Panamint Santo Domingo
Chemehuevi Hopi Cochiti
Acoma Kio
Yavapai Zuni
Mission Apache
Pima
Tohono O'Odham

This map shows the general cultural and geographical regions associated with the tribes represented in this catalogue: Northwest Coast; Plateau; California, including some of the Great Basin; Southwest; Plains; and Woodlands, which includes the Northeast, Southeast, and Great Lakes areas. The Aleutian Islands of Southwest Alaska, home to the Aleuts, are not shown.

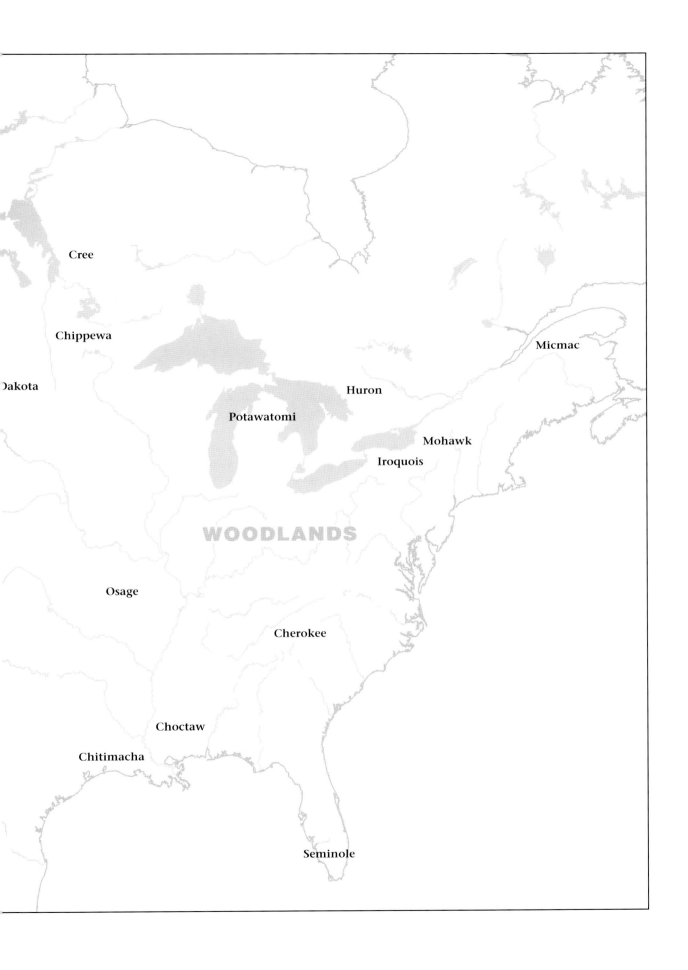

Cree

Chippewa

Dakota

Micmac

Huron

Potawatomi

Mohawk

Iroquois

WOODLANDS

Osage

Cherokee

Choctaw

Chitimacha

Seminole

Lená Taku Wasté

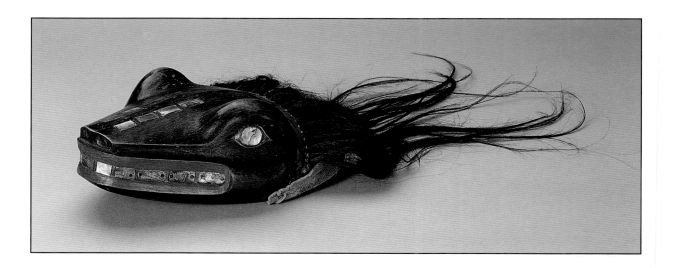

Frog Hat
Tlingit, ca. 1880
Wood, paint, leather, hair, abalone shell
Length: 10¼" (excluding hair); Width: 6¾"; Height: 4"
86.126.24

A primary force behind much Tlingit artistic production is the creation of objects that communicate the importance of a particular family and its crest animals. Finely made objects worn at feasts, dances, and other important occasions indicate the status of the individual or family. This frog hat represents one of the crests of the Ganaxtedi Clan at the village of Klukwan; it would have been worn by a leading member of the clan at special occasions to indicate his entitlement to the rights and privileges associated with the frog crest.

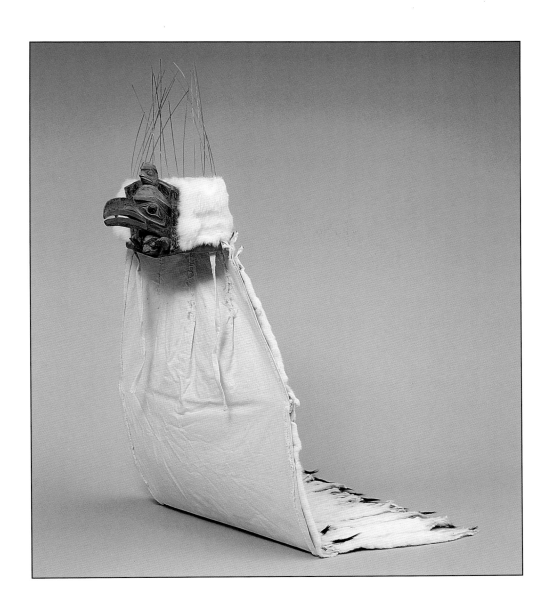

Frontlet Headdress
Bella Coola, ca. 1880
Alder, abalone shell, iron, paint, ermine, sea lion whiskers, canvas, wool, rabbit fur
Length: 70"; Width: 14"
89.52.16

During the nineteenth century, frontlet headdresses became the principal style of ceremonial headdress throughout the Northwest Coast. They were worn by high-ranking individuals who shook bird down out of the crown of the headdress as they danced, causing it to drift and swirl around both dancer and audience. These headdresses usually incorporate a carved wooden plaque that represents a crest animal or mythical being; Bella Coola examples are often deeply carved to represent birds. Inlaid pieces of abalone shell framing the plaque are meant to sparkle dramatically as the wearer of the headdress moves. This frontlet headdress is topped with a crown of sea lion whiskers and finished with rows of ermine skins trailing off the back.

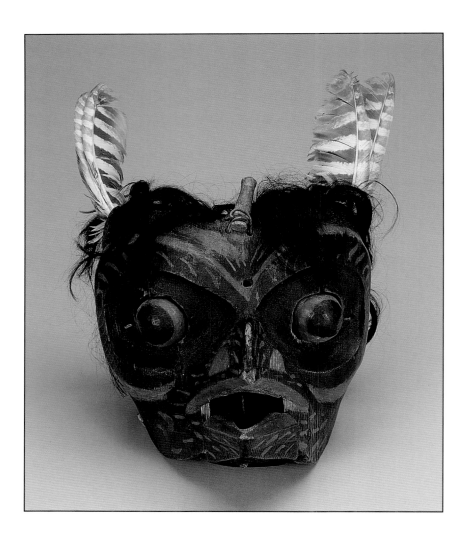

Hawk Mask
Tshimshian, ca. 1880
Cedar, paint, feathers, leather
Height: 18½"; Width: 11"; Depth: 9"
88.43.19

Tshimshian masks, representing a variety of animals, are used in performances at feasts and potlatches. This mask, representing a hawk, is constructed so that the dancer could roll the eyes and cause the beak to open and shut.

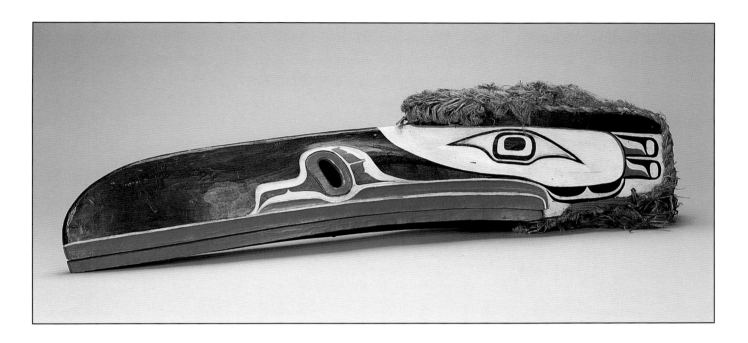

Raven Mask
Kwagiutl, ca. 1930
Cedar, paint, red cedar bark, leather
Length: 47"; Width: 10"; Height: 14½"
1616

This is one of a set of masks worn by dancers at the winter initiation ceremonies of the Kwagiutl Hamatsa Society. The ceremonies dramatize the taming of new initiates as they return to the village. During the rituals, dancers representing supernatural birds wear these large-scale masks while crouching and hopping around the performance area. This raven mask has a long articulated beak that can be snapped shut with a resounding clap during the dance.

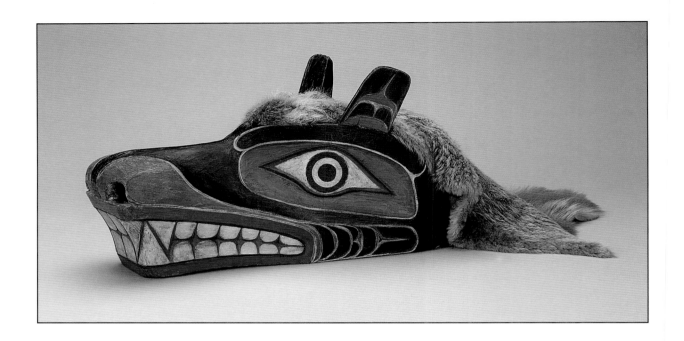

Bear Mask
Attributed to Charley George, Sr. (1889–?)
Kwagiutl (Nakwakhdakw tribe), ca. 1920
Cedar, paint, beaver fur (recent replacement)
Length: 20¼"; Width: 9"; Height: 12" (excluding fur)
88.43.2

The grizzly bear is one of the important crest animals of the Kwagiutl. Masks such as this one were worn in the Tlasula ceremony, which dramatizes the original acquistion of a crest animal by the ancestors of the Kwagiutl. This mask, with its rather blocky carving style, has been attributed to Charley George, Sr., a carver from the community of Blunden Harbor.

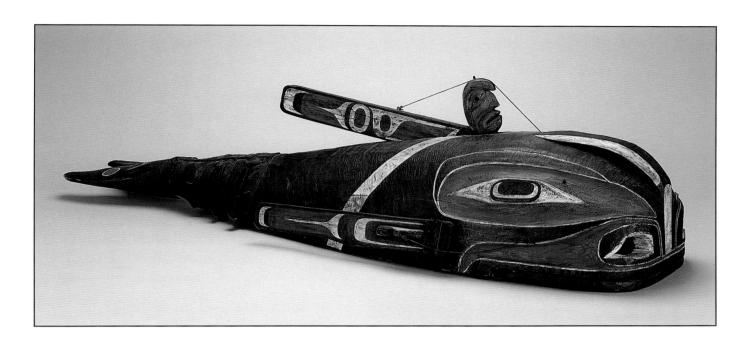

Whale Mask
Kwagiutl, ca. 1900
Wood, paint, cloth, string
Length: 56½″; Width: 15¼″; Height: 14″
89.52.27

Large masks, with articulated elements designed to add to the dramatic effect of the mask when it is used in a dance, are characteristic of the Kwagiutl. The dancer can manipulate the fins and mouth on this mask so that the whale would appear to be swimming.

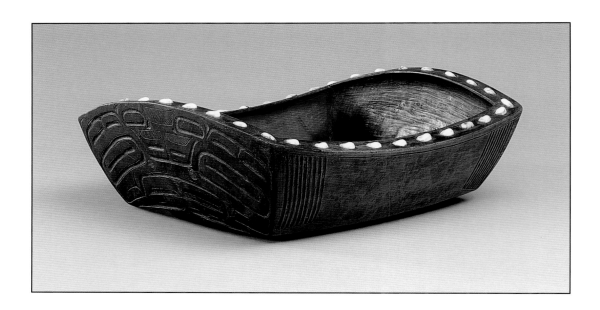

Bowl
Tlingit, ca. 1880
Wood, operculum
Length: 19½″; Width: 16¼″; Height: 6½″
87.88.62

Wooden bowls and dishes for serving food to guests at feasts are often carved in relief or painted with designs representing family crests. Through usage the surface becomes blackened from eulachon oil, a valuable commodity served and eaten with dried fish. Operculum, the material studding the top of the bowl, is derived from the plates that cover the opening of the shell of the marine snail. This valuable material is frequently used to adorn bowls, dishes, and boxes throughout the Northwest Coast.

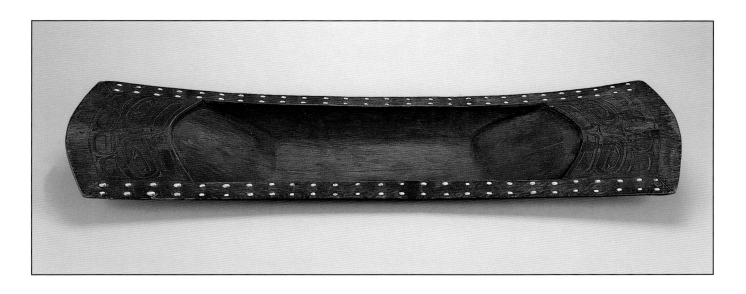

Dish
Tlingit, ca. 1875
Wood, operculum
Length: 52"; Width: 13"; Height: 5 ½"
89.126.29

The long trays used at feasts are usually carved from a single piece of wood.
This tray features crest designs carved in shallow relief at each end and a
double row of opercula along each side.

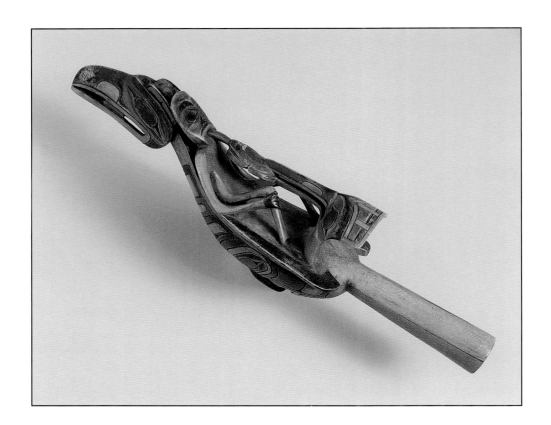

Raven Rattle
Tlingit, ca. 1890
Wood, paint
Length: 14"; Width: 3 ¼"; Height: 3 ¾"
87.88.74

Raven rattles were used throughout the Northwest Coast by people of high rank. The delicate and elaborate carving of these status objects displays the skills of the maker. The body of one of these rattles usually represents a raven, with the head of a hawk carved on its breast. A reclining figure, possibly a shaman, is carved on the back of the rattle. The figure's tongue is joined to the mouth of a bird or frog—in this example, a frog—possibly signifying a transfer of power from one to the other. This may indicate that it was traditionally a shaman's implement. The most common historical use of raven rattles, however, appears to have been as dance rattles carried by high-ranking individuals wearing frontlet headdresses.

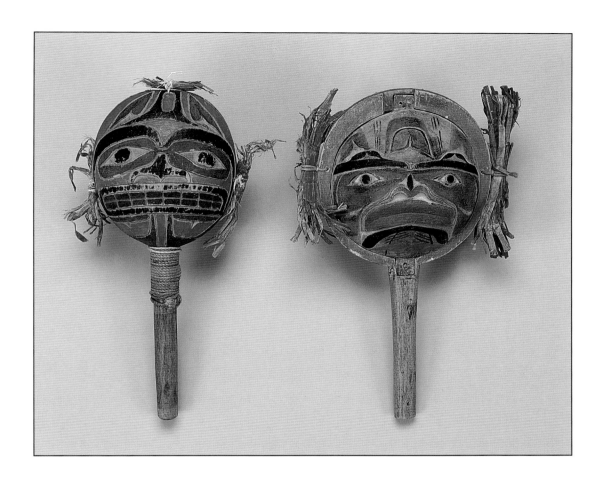

Rattle
Bella Bella, ca. 1890
Wood, paint, cedar bark
Length: 10"; Width: 4¾"; Depth: 2¾"
87.88.78a

Rattle
Bella Bella, ca. 1890
Wood, paint, cedar bark
Length: 10¼"; Width: 6⅜"; Depth: 3"
87.88.78b

Globular rattles are commonly used throughout the Northwest Coast. They are carved in shallow relief from two pieces of wood that are then joined together. The painting emphasizes the carved design which, on these examples, may represent the sun and moon.

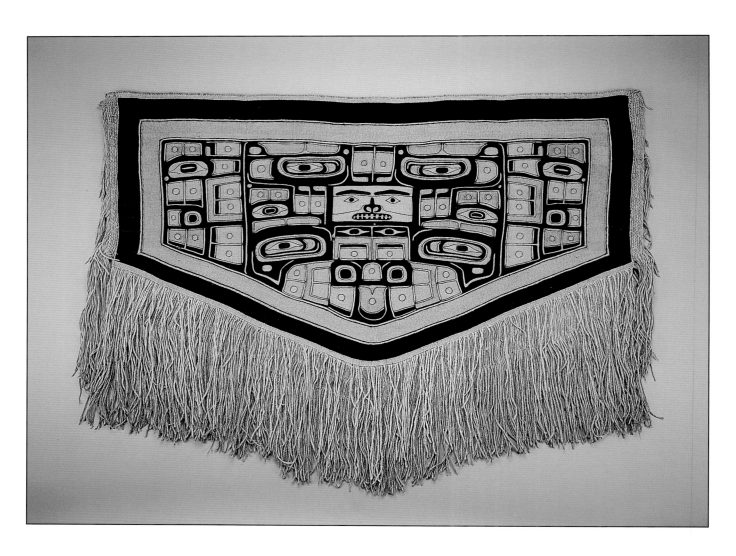

Chilkat Blanket
Tlingit, ca. 1880
Cedar bark, mountain goat wool yarn, cotton yarn
Length: 50; Width: 70"
87.88.80

Chilkat blankets, created by a complex form of tapestry twining, are the best-known textiles of the Northwest Coast. Emblems of nobility, they are prized for their crest significance as well as for their beauty and fine workmanship. The labor-intensive process used to create a Chilkat blanket includes procuring and processing the materials, spinning the mountain goat wool wefts and the cedar bark and wool warps, dying the wefts, and weaving the blanket. The highly abstract designs of crest animals on Chilkat blankets fill the entire design space. The center panel of this design represents a diving whale, with the broad head filling the lower half while the spread-out tail flukes occupy the space along the upper border. A rectangular human face appears in the center of the whale's body.

Button Blanket
Tlingit, ca. 1890
Wool cloth, mother-of-pearl buttons
Length: 53¼"; Width: 65¼"
1615

Button blankets are an excellent example of Northwest Coast artists adopting materials introduced by Europeans and combining them with traditional style to create a new art form. Button blankets are worn and displayed at important occasions. The most common version is a dark blue woolen blanket with a red border on the top and sides. A crest animal appliqued in red flannel and outlined in mother-of-pearl buttons occupies the center of the blanket. In this instance the crest animal is a beaver, identifiable from the upright ears and large incisors.

Apron
Kwagiutl, ca. 1900
Wool cloth, glass beads, puffin beaks, brass thimbles
Length: 33"; Width: 34"
86.126.28

Northwest Coast beadwork began to develop during the last half of the nine-teenth century. Kwagiutl beadwork is primarily decorative, with designs that often include curvilinear and floral elements beaded on cloth garments. This apron is also adorned with puffin beaks and brass thimbles, which would have made a pleasing sound when the wearer moved.

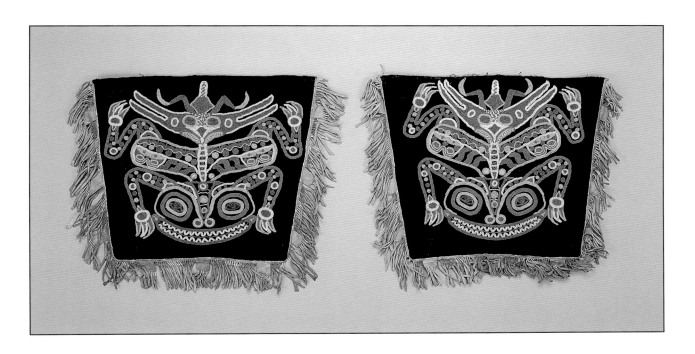

Leggings
Tlingit, ca. 1880
Wool cloth, leather, glass beads, porcupine quills
Length: 14½"; Width: 16"
1611.3a and 1611.3b

It was common for Tlingit people, on important occasions, to wear garments decorated with designs of crest animals. By the nineteenth century, with the availability of glass beads from European sources, these designs were sometimes created with beadwork. Some beaded designs are stylistically similar to those that are woven or painted; others, however, such as the frog designs on these leggings, establish new conventions based on the introduced medium while still serving as a reference to clan affiliation.

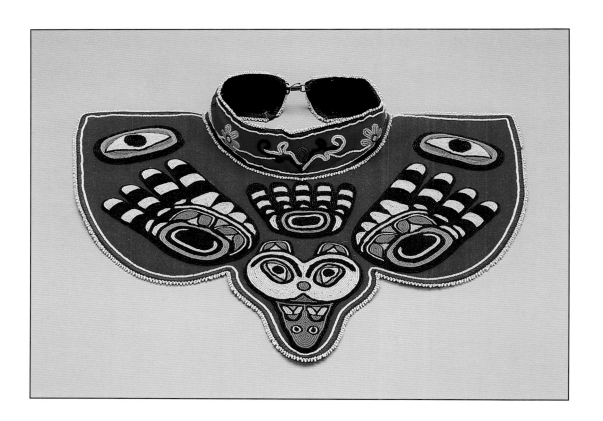

Collar
Tlingit, ca. 1880
Wool cloth, glass beads
Length: 15"; Width: 16"
1611.2

The shape of the red wool cloth on this collar refers to the outstretched wings of a bird that is also represented in the beadwork. The stylized design, in terms of the ovoids and abstracted layout, is similar to conventions used in Tlingit carving and painting.

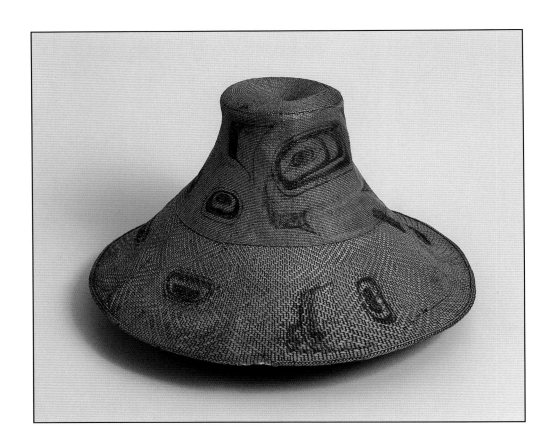

Hat
Tshimshian, ca. 1900
Spruce root, paint
Height: 8"; Diameter: 12"
91.95.23

Hats made from twined spruce root are frequently decorated with crest designs. The abstracted designs on this hat are carefully painted in black and then outlined with red. The design follows the usual Northwest Coast style of displaying the various parts of an animal over the entire surface of the object.

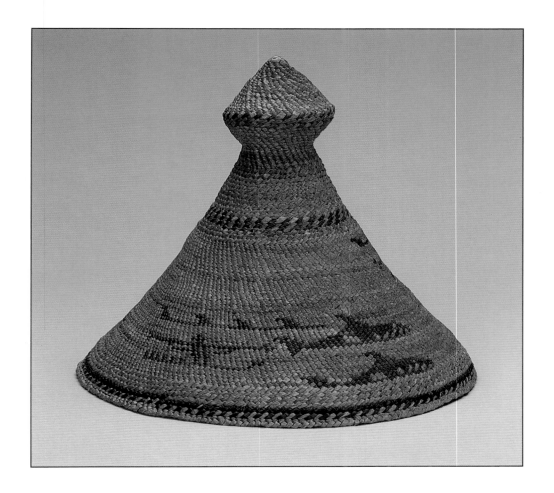

Hat
Nuu-Chah-Nulth, ca. 1900
Spruce root, cedar bark
Height: 8"; Diameter: 10"
627

Nuu-Chah-Nulth hats, made from twined spruce root and cedar bark, characteristically have a conical form with a knob at the top. The design, which is woven into the surface rather than painted onto it, is a hunting scene that depicts Nuu-Chah-Nulth fishermen harpooning whales from boats.

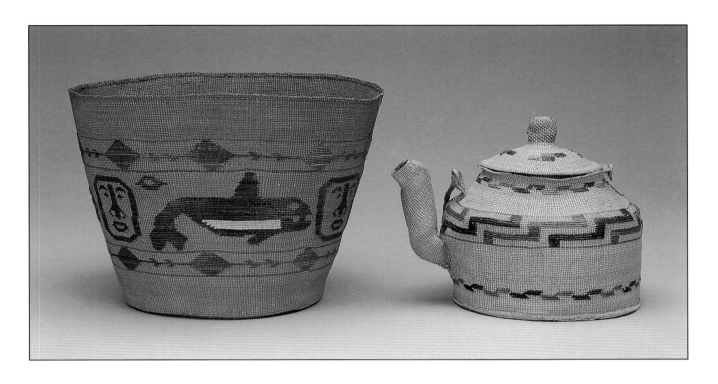

Basket
Tlingit, ca. 1900
Spruce root, grass
Height: 6"; Diameter: 8"
434

Basketry Teapot
Tlingit, ca. 1920
Spruce root, grass
Height: 4¾"; Length: 6½"; Width: 5"
1864

Tlingit baskets are most often twined from spruce root and decorated with brightly colored elements in false embroidery, a technique in which the decorative elements are woven onto the exterior of the basket and do not appear on the interior. By the twentieth century, many baskets were being made expressly for sale to tourists and non-Native collectors. As a response to that market many weavers developed new shapes and incorporated figurative designs in order to make their baskets more marketable.

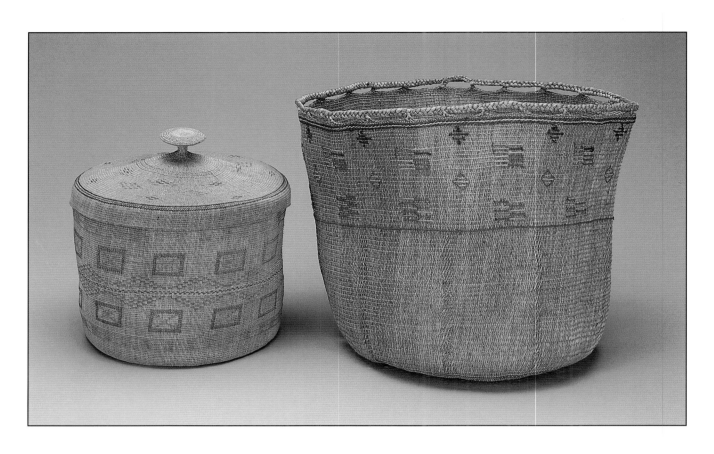

Lidded Basket
Aleut, ca. 1900
Sea grass, silk thread embroidery
Height: 9"; Diameter: 9"
423a and 423b

Basket
Aleut, ca. 1900
Sea grass, silk thread embroidery
Height: 11"; Diameter: 13"
430

Aleut baskets, made from soft, flexible grasses, are woven so finely that the surface feels like cloth. The lidded basket on the left is twined, while the basket on the right with the braided rim finish is constructed by open twining with a parallel warp element. The small, isolated geometric designs on most Aleut baskets are embroidered with wool yarn or silk thread.

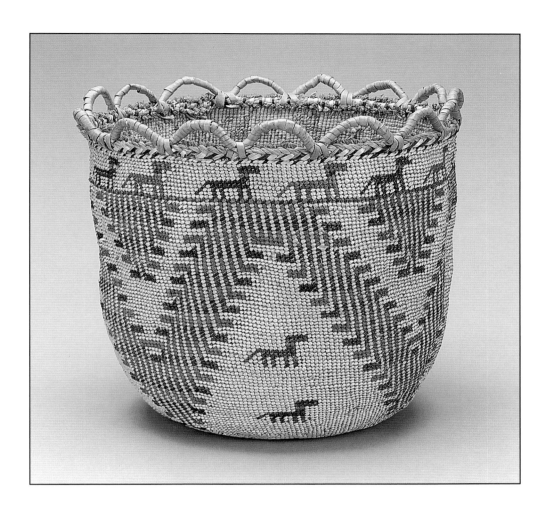

Basket
Twana, ca. 1900
Cattail leaves, beargrass, cedar bark
Height: 10⅞"; Diameter: 13"
91.95.24

The Twana, or Skokomish, frequently make cylindrical, open-mouthed baskets using an overlay twining technique from materials that leave the basket somewhat flexible. The designs on these baskets characteristically feature a band of animal or bird figures below the rim, with a zigzag design that encircles the entire basket. The figures on this basket represent wolves, recognizable by their down-turned tails.

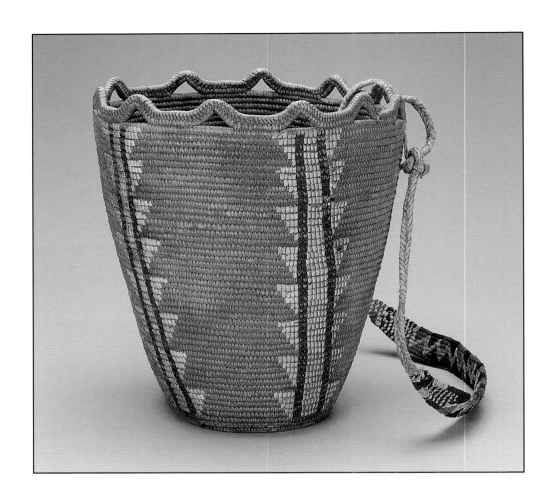

Basket with Tump Line
Klickitat, ca. 1900
Cedar root, beargrass, horsetail root, vegetal fiber
Height: 14¾"; Diameter: 12½"
649

Coiled cedar root baskets are generally associated with the Klickitat, although they are also made by many tribes of the Columbia River Plateau. These pail-shaped baskets with looped rims are used to gather berries. Smaller versions are attached to the waist, while larger baskets are worn on the back and supported by a hand-woven tump line. They are decorated by imbrication, an overlay technique wherein the design elements are sewn onto the outer surface of the basket.

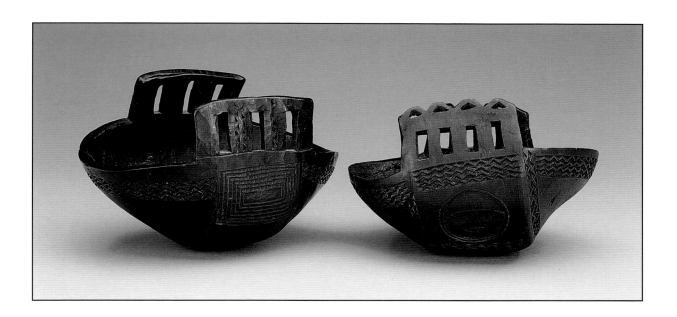

Bowl
Wasco, ca. 1800–1850
Mountain sheep horn
Length: 7½"; Width: 6"; Height: 5"
87.88.67

Bowl
Wasco, ca. 1800–1850
Mountain sheep horn
Length: 7"; Width: 6"; Height: 4½"
89.52.34

Several tribes living along the middle Columbia River, including the Wasco, made bowls and other objects from mountain sheep horns. Pieces of horn were steamed until soft, spread open, and then formed into a shape with raised ends and flaring sides. The bowls are decorated with a combination of carved geometric shapes, zigzag lines, and round human faces.

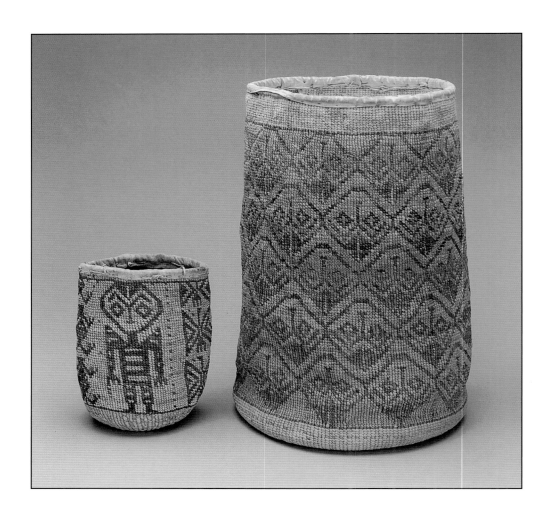

Cylinder Bag
Wasco, ca. 1910
Vegetal fiber
Height: 6¼"; Diameter: 4"
1753

Cylinder Bag
Wishxam, ca. 1880
Vegetal fiber
Height: 12⅞"; Diameter: 8¼"
496

Plain and wrapped twined cylinder bags of the Wasco and Wishxam are noted for their distinctive figurative designs. These same designs are also used to decorate a variety of objects in techniques that include carving, basket weaving, and beadwork. The larger bag carries an all-over design of upside-down stylized human faces. The smaller bag features a human figure with the same style of face as those on the larger bag, as well as birds and frog-like creatures.

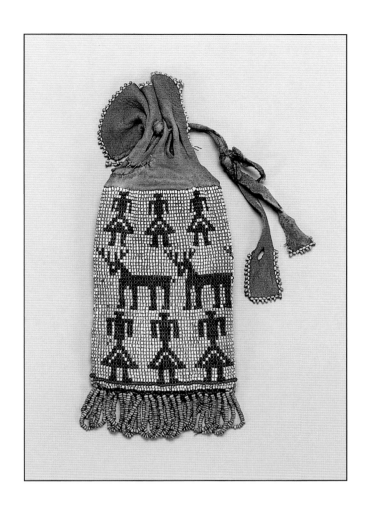

Pouch
Ellen Underwood (1841–?)
Wasco, ca. 1890–1900
Leather, glass beads
Length: 7 ⅞"; Width: 3"
87.88.101

Ellen Underwood was born in the Wasco village of Nenoothlect on the southern bank of the middle Columbia River. She developed a unique style of beaded leather pouch in which the beads are strung on paired threads and twined around a loose warp. This produces a continuous tube, which is then sewn shut at the bottom. The design, although inspired by Wasco traditions, is also distinctly her own. It consists of two horizontal rows of female figures wearing triangular skirts, and a row of elk, all beaded in a single color against a solid white background.

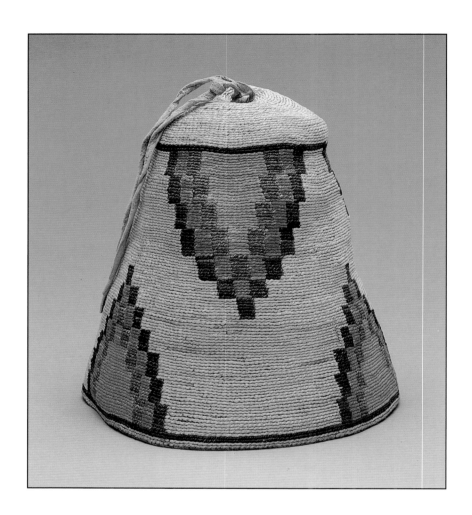

Woman's Hat
Nez Perce, ca. 1900
Vegetal fiber, wool yarn, leather fringe
Height: 7 ¼"; Diameter: 6 ½"
1160

Twined basketry hats made from Indian hemp or cornhusk are important items of Columbia Plateau women's clothing reserved for special occasions. The usual pattern on these hats is a zigzag design with three triangular forms at the bottom and three at the top. This hat follows the usual conventions: the stepped triangular forms are made of wool yarn that is false embroidered.

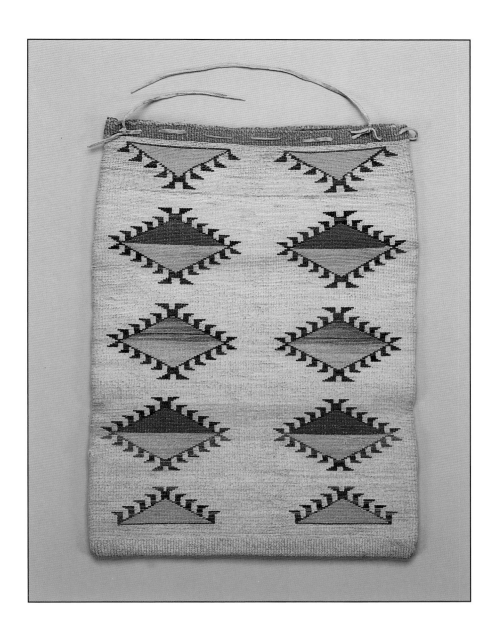

Flat Bag
Nez Perce, ca. 1900
Vegetal fiber, wool yarn, leather handle
Length: 22½"; Width: 16"
28

Twined flat bags made from vegetal fiber, usually a combination of Indian hemp and cornhusk, were made by the Nez Perce and all the other tribes of the Columbia Plateau region. Used as storage bags for roots and other plant materials, these bags are decorated with different designs on each side. The design on this bag, diamonds and triangles bordered by projecting triangles, is a variation of a design known as "quail tracks."

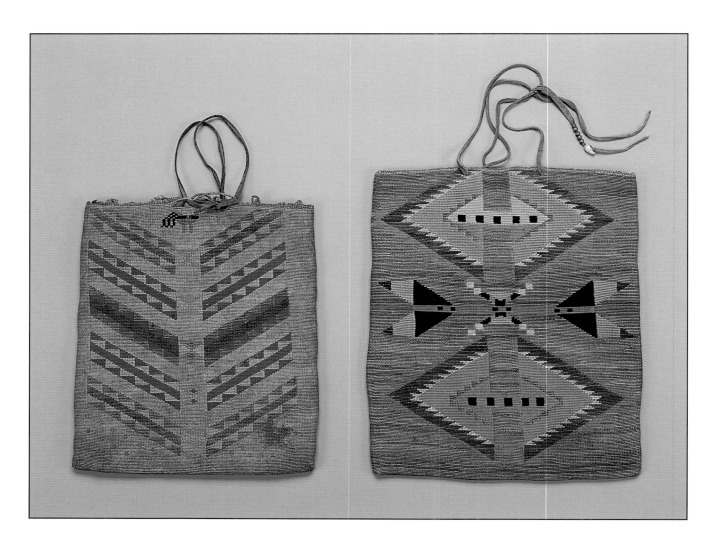

Flat Bag
Nez Perce, ca. 1890
Vegetal fiber, wool yarn, leather handles
Length: 11¼"; Width 9½"
253

Flat Bag
Nez Perce, ca. 1900
Vegetal fiber, wool yarn, leather handles, metal beads, shell
Length: 13"; Width 11"
1353

An unlimited number of designs, both geometric and figurative, are used on flat bags. The design layout can be symmetrical, placed on the central portion of the bag, or divided horizontally.

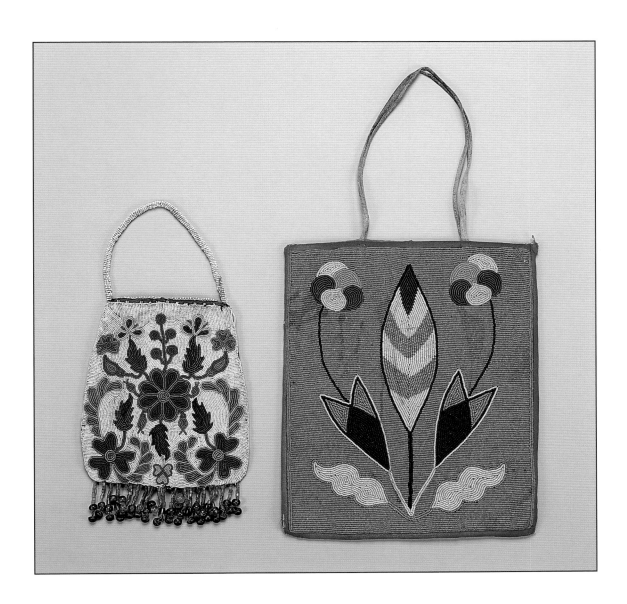

Beaded Flat Bag
Nez Perce, ca. 1890
Glass beads, cotton cloth lining
Length: 9"; Width: 7"
1788

Beaded Flat Bag
Plateau, ca. 1890
Glass beads, cotton cloth lining, leather handles
Length: 12"; Width: 10"
1552

Twined flat bags are the inspiration for the beaded flat bags of the Plateau. The flat surface of one side of the bag acts as a canvas for an endless variety of beaded designs. The reverse side is usually left unbeaded. Although both of these bags are decorated with symmetrical floral designs, the smaller bag is beaded in the contour style, in which the floral design is outlined first and the background is then filled in with rows of beads that follow the contour of the design.

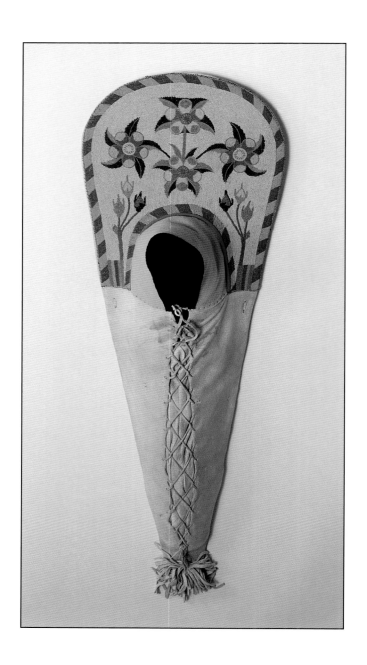

Cradle
Salish, ca. 1890
Wood frame, wool cloth, leather, glass beads
Length: 41"; Width: 15; Depth: 5½"
87.70.6

Plateau cradles are generally constructed of a flat wooden frame, rounded at the top and tapering at the bottom, with tanned leather stretched over it. The leather is laced together down the front, and a cloth hood protects the baby's head.

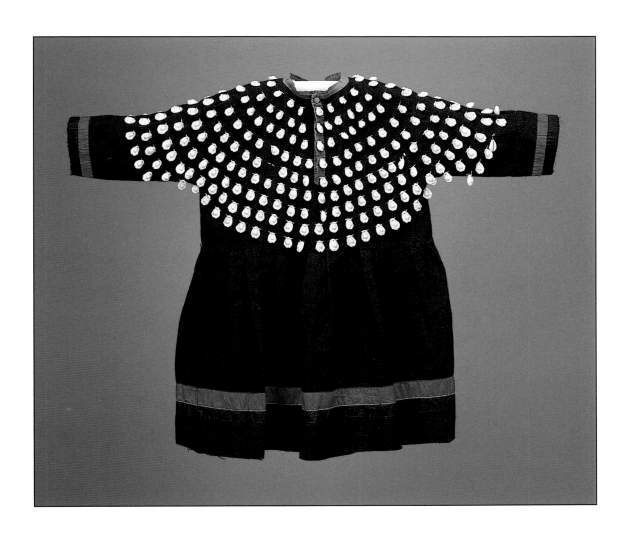

Girl's Dress
Nez Perce, ca. 1890
Wool cloth, silk ribbon, cotton cloth binding, leather ties, cowrie shells
Length: 23¾"; Width: 31¼"
1797

Trade goods such as manufactured cloth, silk ribbon, and cowrie shells were easily absorbed into the artistic traditions of the Plateau people. This little girl's dress incorporates wool cloth and cowrie shells to create a garment that was worn on special occasions.

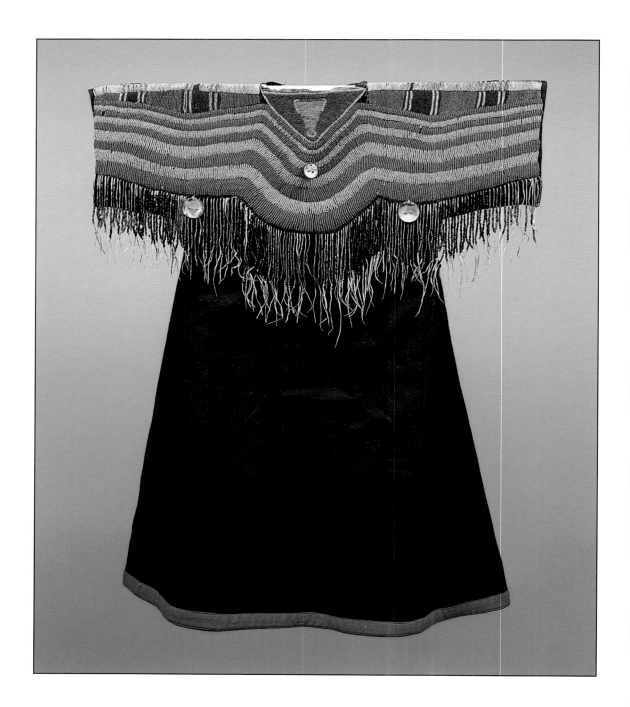

Dress
Nez Perce, ca. 1890
Wool cloth, leather fringe, glass beads, metal beads, shell beads, abalone shell disks
Length: 45 ½"; Width: 39 ¾"
87.88.18

The undulating rows of beadwork across the yoke of this dress refer to the traditional hide dresses of the Nez Perce and other Plateau tribes. They give the dress a kinetic energy further emphasized by the leather fringe strung with glass beads and the three hanging abalone shell disks.

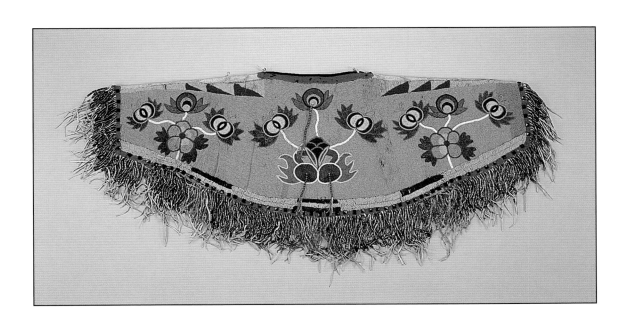

Dress Yoke
Nez Perce, ca. 1890
Wool cloth lining, glass beads, metal beads, leather fringe
Length: 16"; Width: 43"
1386

The yoke, often completely beaded, was the ornamental focus of Plateau dresses. This dress yoke features a beaded design, with stylized floral elements that are nearly symmetrical and a beaded fringe. It took a long time to complete such a large amount of beadwork, so it is not surprising that particularly striking yokes like this one were saved after the dress itself wore out.

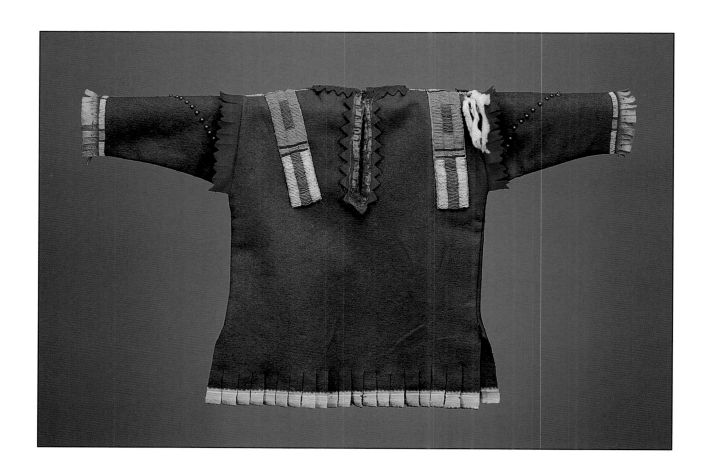

Boy's Shirt
Umatilla, ca. 1890
Wool cloth, silk ribbon, leather, glass beads, metal beads, ermine strips
Length: 19 ¼"; Width: 30"
89.52.35

Most children's clothing among Plateau peoples such as the Umatilla was simply a smaller version of adult garments. A great deal of time and energy was spent providing children with articles of clothing and accessories so that they could look their best on special occasions. This remarkable wool shirt decorated with beaded strips and adorned with metal beads and ermine strips reveals one family's devotion to their child.

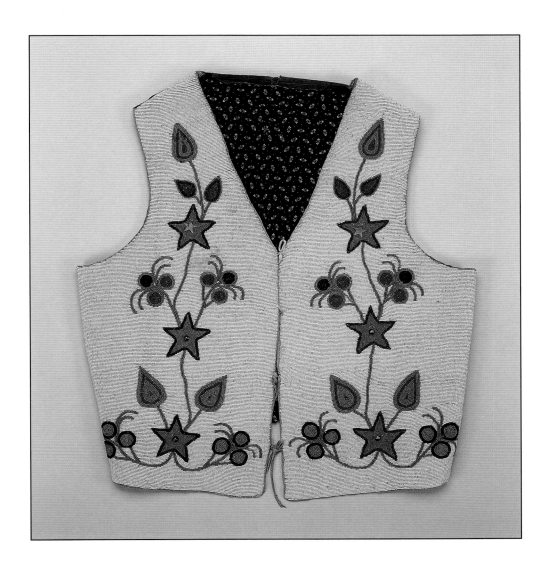

Vest
Plateau, ca. 1880–1900
Cotton cloth, glass beads, metal trim
Length: 21"; Width: 20"
1644

Plateau men often wore vests such as this one, usually with beaded decoration restricted to the front. The designs on this vest adhere to the stylistic characteristics of other Plateau beadwork in terms of its overlay beading technique, symmetrical design layout, and the motif of stylized floral elements in a wide range of colors on a solid color background.

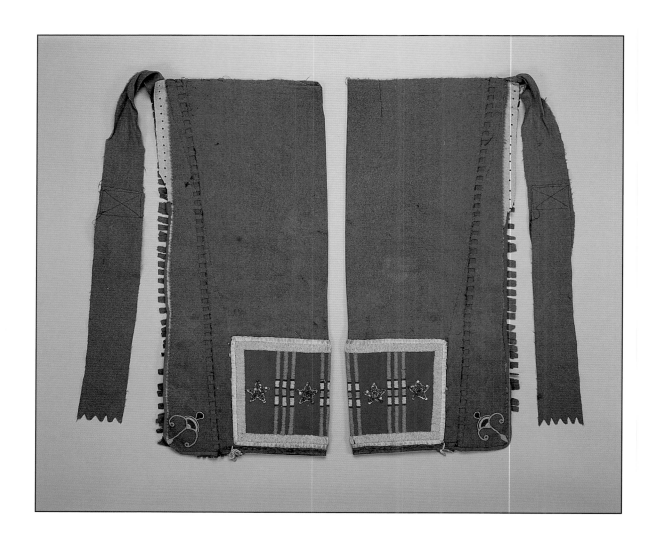

Leggings
Plateau, ca. 1890
Wool cloth, glass beads, metal sequins
Length: 29 ¾"; Width: 13 ½"
249a and 249b

Men's leggings made from wool blankets, and with decorated ankle panels, are unique to the peoples of the Plateau and their neighbors of the north-western Plains. This pair is more elaborate than most, with fringed edges, beaded panels, and sequins sewn into the shape of stars.

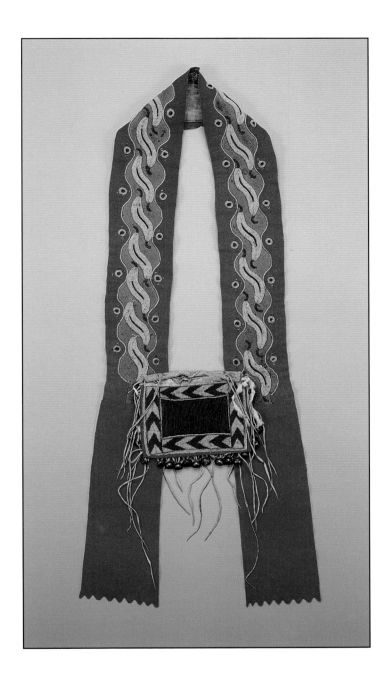

Bandolier Bag
Cayuse, ca. 1870
Wool cloth, leather, glass beads, brass bells, ermine strips
Length: 37"; Width: 13"
243

Men's bandolier bags are worn over the shoulder. Although functional, they are also decorative. The bright red wool with pendant straps, beadwork, fringe, and bells would certainly have been an impressive sight when seen on a horseman in a parade.

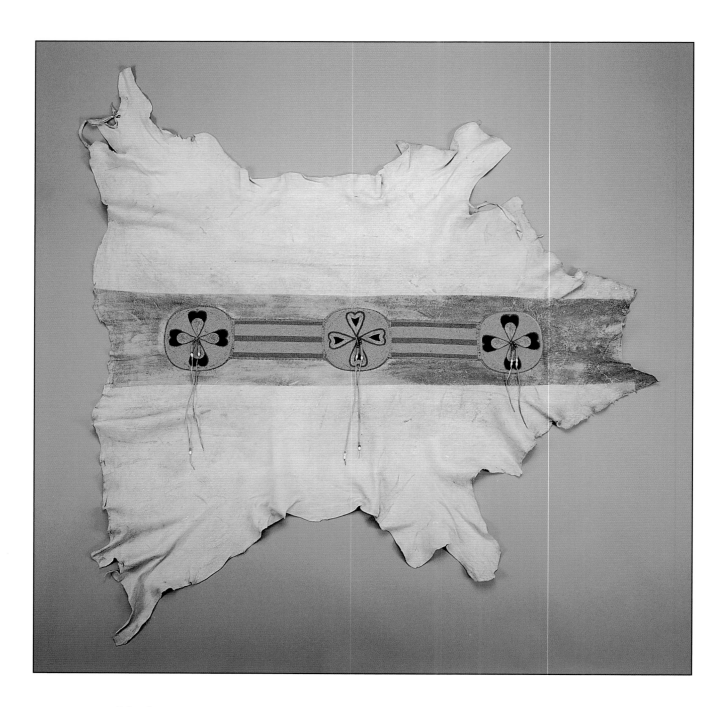

Blanket
Salish, ca. 1880
Antelope hide, pigment, glass beads, metal beads
Length: 54"; Width: 55"
1085

Traditionally, blankets made from either hides or wool cloth served as both articles of clothing and essential household items. Often they are decorated with beaded strips sewn along the middle of the blanket. The beaded strip on this blanket is emphasized by its placement within the band of green paint.

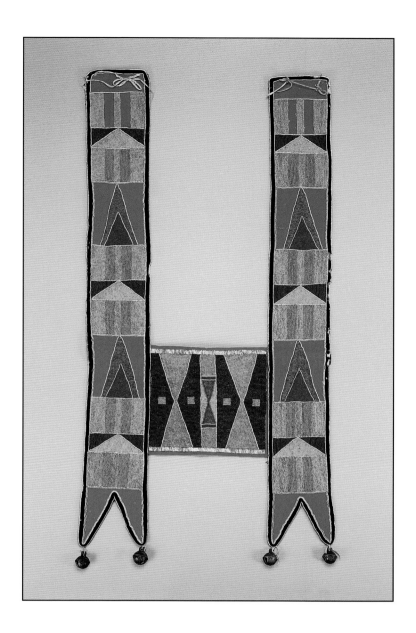

Horse Collar
Nez Perce, ca. 1880
Wool cloth, cotton cloth, leather ties, glass beads, brass bells
Length: 41"; Width: 21"
87.88.104

Traditional Nez Perce culture places a great value on horses, and both horses and riders wear their finest trappings during parades held at annual encampments and celebrations. This beaded collar is meant to hang from a horse's neck. The beadwork is sewn onto the red wool cloth with an overlay stitch that alternates between horizontal and vertical orientation in the various design areas. The geometric design emphasizes elongated triangles and diamonds in colors of predominantly the same value. The subtle color shift in the blue background is unusual and provides an added feeling of dimension.

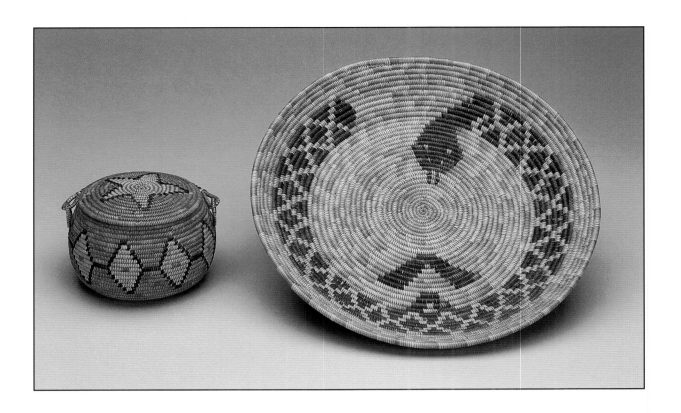

Lidded Basket
Mission, ca. 1920
Juncus, devil's claw, grass
Height: 4"; Diameter: 6"
1758

Basket
Mission, ca. 1900
Juncus, devil's claw, grass
Height: 2"; Diameter: 13¼"
530

The term Mission Indian refers to the various Native American groups in southern California that were forced to live at the missions established by the Spanish beginning in the 1700s. Although their removal to the missions severely disrupted their traditional way of life and caused their population to decrease dramatically, some of their cultural expressions survived, including the art of basket making. Mission Indian baskets are usually coiled and made from juncus, which is what gives the surface its mottled golden color; the dark elements are made from devil's claw. The most common form of Mission basket is a round, shallow bowl such as the one on the right, although lidded baskets are also typical.

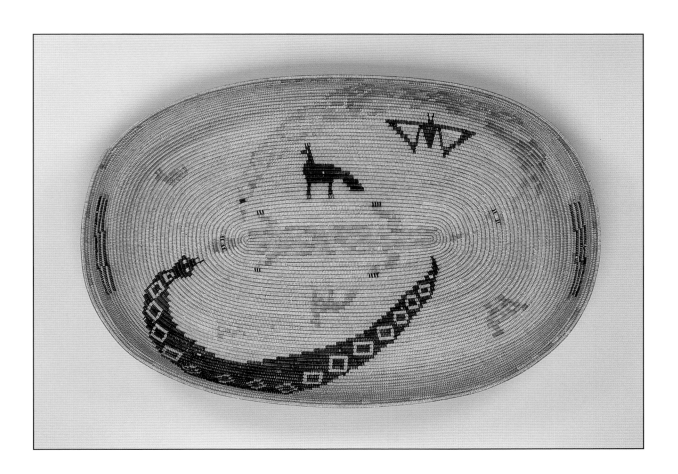

Basket Tray
Mission, ca. 1920
Juncus, devil's claw, grass
Height: 2¼"; Length: 26"; Width: 17½"
91.95.31

This basket tray, in the complexity of its design and the quality of its execution, is perhaps the ultimate expression of the Mission basket weaver's art. It was probably made expressly to be sold to a non-Native collector. Fancy Mission baskets destined for the marketplace often incorporated human and animal figures, especially snakes. This complex composition features a lizard in the center with opposing rattlesnakes curling up the sides of the basket. A bat and several quadrupeds with long flowing tails complete the design.

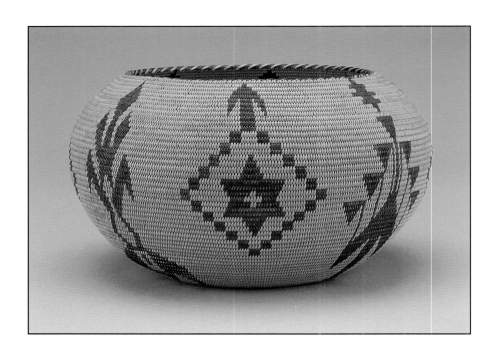

Basket
Annie Poole McBride (1874–?)
Paiute, ca. 1920–1930
Willow, yucca root
Height: 4¾"; Diameter: 9"
91.95.37

Annie Poole McBride, a master Paiute basket maker, lived around Bishop, California. This finely coiled basket is identified as her creation by the six-pointed star often used on her baskets. Many Paiute basket makers entered their works in competition at local fairs, which not only gained fame and financial reward for the winning artists but also stimulated ever-increasing quality of workmanship and complexity of design.

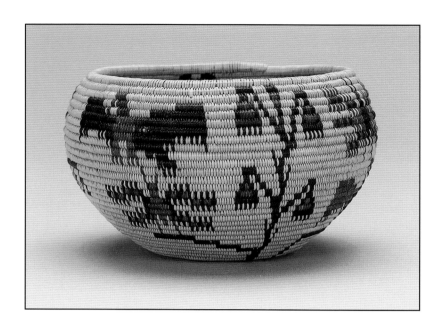

Basket
Sarah Mayo (ca. 1860–1945)
Washoe, ca. 1910
Willow, redbud, dyed bracken fern root, undyed bracken fern root
Height: 3 ½"; Diameter: 5 ½"
91.95.36

Sarah Mayo was a renowned and innovative Washoe basket maker during the early twentieth century. She sold many of her baskets to tourists in the Carson, Nevada, area, and one of her baskets was presented to President Woodrow Wilson. Sarah Mayo was one of the first Washoe basket makers to make extensive use of figurative motifs. She also frequently used color and overlapping to give an illusion of depth to the design. The design on this small bowl is of trees with birds and other winged creatures.

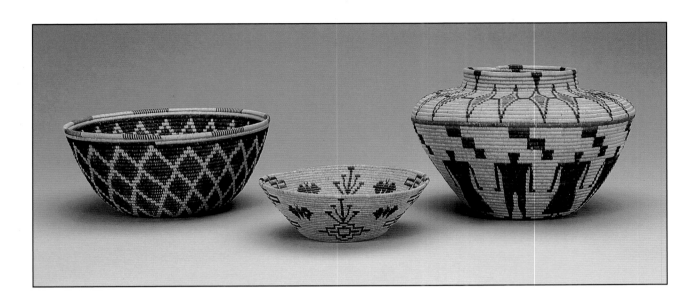

Basket
Panamint, ca. 1920
Willow, devil's claw
Height: 3 ⅛"; Diameter: 7 ⅛"
91.95.41

Basket
Panamint, ca. 1920
Willow, devil's claw, yucca root
Height: 2"; Diameter: 5 ½"
91.95.39

Basket
Panamint, ca. 1920
Willow, devil's claw, yucca root
Height: 5"; Diameter: 7 ½"
91.95.42

Panamint baskets are usually coiled and are traditionally decorated with geometric designs. Tick marks around the rim are another traditional element. By about 1920 the designs on Panamint baskets were becoming increasingly complex, incorporating figurative motifs such as humans, birds, animals, and butterflies.

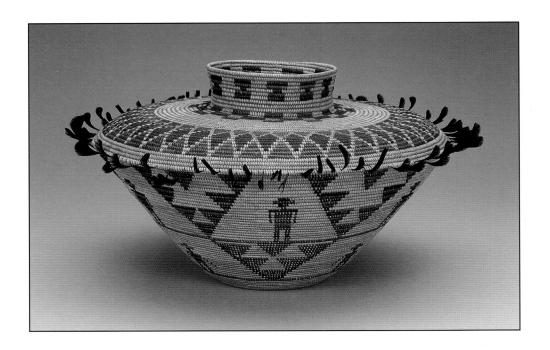

Basket
Yokuts, ca. 1900
Sedge, bracken fern root, redbud, quail feathers
Height: 9"; Diameter: 14½"
91.95.29

The Yokuts are some forty to sixty linguistically related tribal groups that historically lived in the San Joaquin valley and adjacent Sierra Nevada foothills of California. They made a variety of coiled basketry forms, including jars with a distinct flat shoulder and a short, vertical neck. Figurative and representational motifs woven in red and black were common, as were the quail topknots that adorned many Yokuts baskets. The interlocking diamond pattern on the shoulder of this basket is meant to represent a rattlesnake.

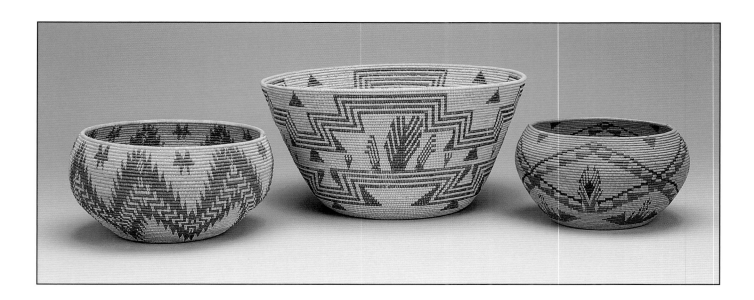

Basket
Maidu, ca. 1900
Willow, redbud, bracken fern
Height: 6½"; Diameter: 10½"
91.95.29

Basket
Maidu, ca. 1910–1920
Willow, redbud, bracken fern
Height: 8"; Diameter: 15"
1343

Basket
Maidu, ca. 1920
Willow, redbud, bracken fern
Height: 5½"; Diameter: 9"
1763

Although the Maidu made both twined and coiled baskets, the designs on coiled baskets are generally more complex. The continuous designs on these three baskets consist of both positive and negative geometric elements.

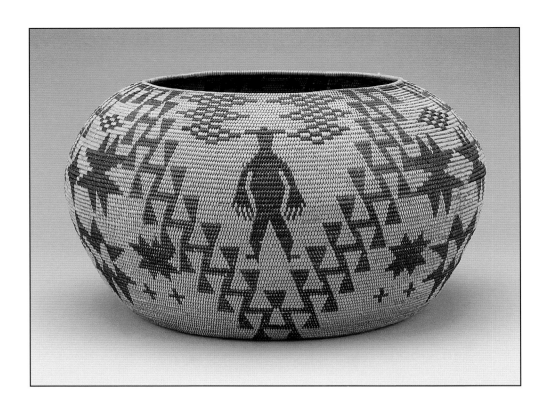

Basket
Maidu, ca. 1920–1930
Willow, redbud, bracken fern
Height: 9"; Diameter: 14"
91.95.38

The globular shape and extensive, complex design of this basket identify it as Maidu. This is an excellent example of the type of fancy baskets, often decorated with figurative designs, that began to be made by Maidu weavers in the 1920s. This one includes numerous crosses and eight-pointed stars, as well as a male figure, with exaggerated hands, wearing what could be a hat or headdress. Baskets with such extensive designs — demonstrating the skill of the weaver — were almost certainly made to be sold.

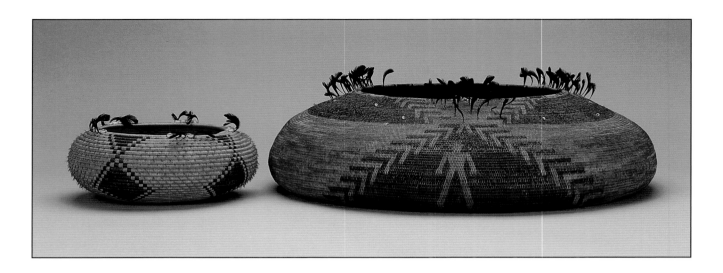

Basket
Pomo, ca. 1900
Willow, sedge root, bulrush root, clam shell beads,
 quail feathers
Height: 3½"; Diameter: 8"
91.95.34

Basket
Pomo, ca. 1900
Willow, sedge root, bulrush root, clam shell beads,
 quail feathers
Height: 5"; Diameter: 18"
91.95.33

The Pomo are seven distinct cultural groups that historically occupied the California coast from south of the Russian River northward to the Fort Bragg area and inland to the region around Clear Lake. Although the Pomo made a variety of baskets, they are best known for finely coiled baskets such as these. The basket on the left is constructed with a three-coil foundation; the basket on the right uses a single-coil foundation. The woven designs on Pomo baskets are usually geometric; figurative designs are rare. Pomo weavers often add feathers and clam shell beads as further ornamentation. The dark plumes are quail topknots, frequently used as accents around the basket rims. The red feathers, from the acorn woodpecker, are very fine; each tuft on the basket is made of several feathers that have been twisted together.

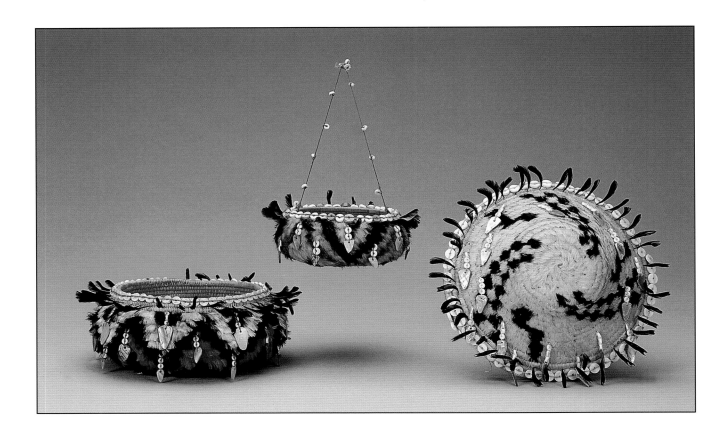

Gift Basket
Pomo, ca. 1930
Willow, sedge root, clam
 shell beads, abalone shell,
 meadowlark feathers, quail
 feathers, mallard feathers,
 flicker feathers, dogbane
Height: 3"; Diameter: 6½"
538

Gift Basket
Pomo, ca. 1900–1920
Willow, sedge root, clam shell beads,
 magnesite beads, abalone shell,
 meadowlark feathers, quail feathers,
 mallard feathers, oriole feathers,
 bluebird feathers, dogbane
Height: 2"; Diameter: 5"
1663

Gift Basket
Pomo, ca. 1940
Willow, sedge root, clam
 shell beads, abalone
 shell, meadowlark
 feathers, quail feathers,
 mallard feathers
Height: 2"; Diameter: 8"
91.95.35

Feathered baskets were an important trade item and a symbol of wealth among the Pomo. They were considered appropriate gifts at special occasions and were used as offerings at funerals and mourning ceremonies. The brightly colored feathers, added to the basket as it is made, provide a design mosaic, while the basketry foundation is left plain. Flat saucer-shaped hanging baskets, like the one on the right, were originally decorated only in red feathers. The addition of other colors and patterns was an innovation that began around 1900 as a response to collectors' wishes. Handmade clam shell beads added around the rim along with triangular pieces of abalone shell as pendants increased the traditional value of the basket. Magnesite beads were sometimes used as an alternative to clam shell beads. Referred to as "Indian gold," magnesite is white when it comes out of the ground. Pomo men would ceremonially heat it over a fire—causing the magnesite to turn a golden orange color—before working it into beads.

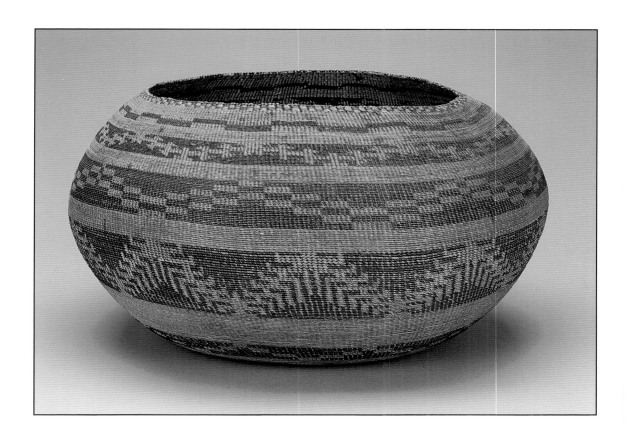

Basket
Pomo, ca. 1920
Willow, sedge root, redbud
Height: 11"; Diameter: 20"
91.95.32

Large twined baskets such as this one were traditionally used by the Pomo for cooking or storage. As on most Pomo baskets of this type, the geometric designs are contained within horizontal bands, or registers. Many of the conventional designs on Pomo baskets have been given names; the design in the widest register of this basket is referred to as "arrowheads with quail plumes."

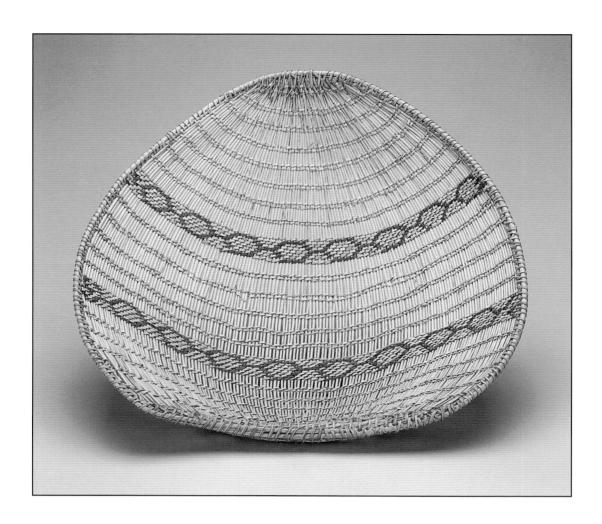

Parching Tray
Northern California, ca. 1920
Willow, redbud
Height: 19½"; Width: 18½"
522

Many Native American groups throughout western North America made baskets with an open weave. These functional baskets, often shaped like large scoops, were used primarily for harvesting and processing plant materials for food. This parching tray with its open weave and twined decoration would have been used to sift and dry acorns.

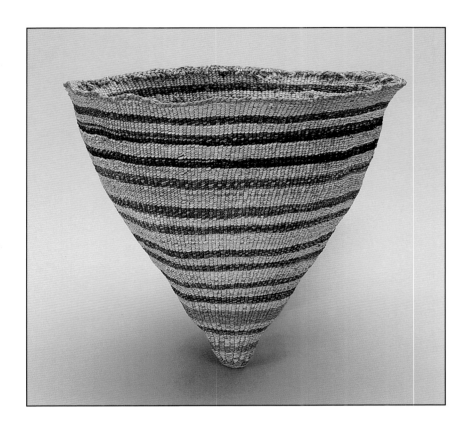

Conical Basket
Klamath, ca. 1900
Tule
Height: 10"; Diameter: 9 ½"
704

Many tribes made conical baskets in a variety of sizes. People often carried these "burden baskets" on their backs while gathering plant materials. Klamath baskets are characteristically made from tule, which gives a basket some slight flexibility.

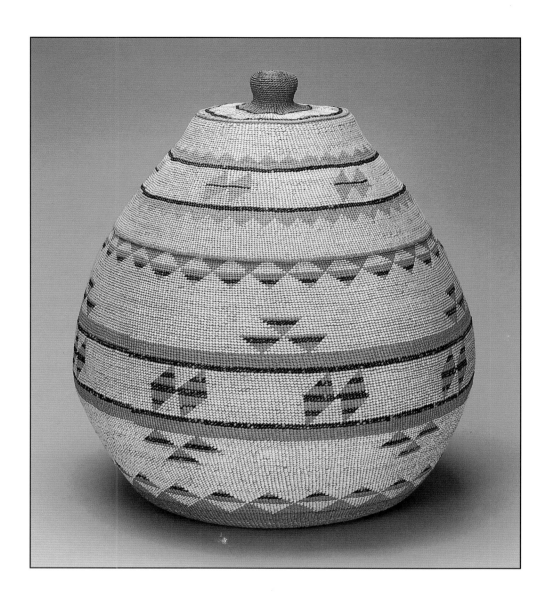

Lidded Basket
Hupa, ca. 1920
Cedar bark, hazel, grass, fern stem
Height: 21"; Diameter: 18"
91.95.55

Extremely large baskets were useful for storing plant materials that would later be processed into food. Lids on these storage baskets protected the materials inside from moisture and insects. This basket is typical of many Hupa baskets, with repetitive geometric motifs divided into horizontal registers encircling the entire basket.

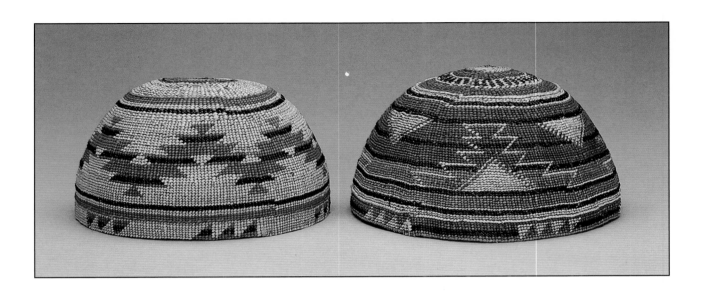

Basketry Hat
Yurok, ca. 1900
Conifer root, hazel, grass, fern stem
Height: 3¾"; Diameter: 7¾"
472

Basketry Hat
Karok, ca. 1900
Conifer root, hazel, grass, fern stem
Height: 3½"; Diameter: 7"
473

Among the Yurok and other tribes of northwestern California, basketry hats were an essential item of women's clothing. They are worn at important social and ceremonial occasions as an affirmation of cultural identity and an indication of wealth. Basketry hats are the finest examples of basket making from this region. They are twined with a half-twist overlay and decorated with a combination of geometric and representational designs that repeat around the entire hat in the usual color combinations of white, brown, yellow, and black.

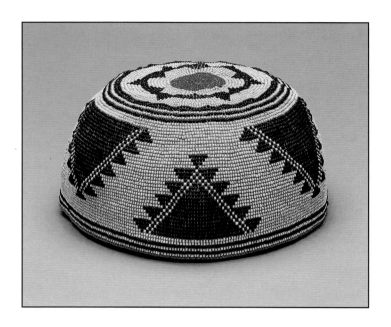

Beaded Hat
Klamath, ca. 1900
Glass beads
Height: 3½"; Diameter: 7"
259

Beaded hats are an alternative to the more common basketry hats. This Klamath hat is made entirely from beadwork that probably was originally sewn onto a basketry foundation. Although it is beaded rather than woven, the designs are typical of those on basketry hats.

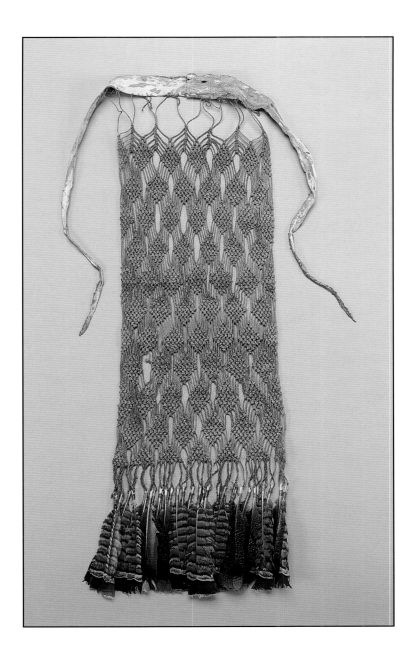

Head Net
Hupa, ca. 1900
Vegetal fiber, grouse feathers
Length: 26"; Width: 13 ½"
1624

Regalia worn by dancers of northwestern California in the White Deerskin Dance included head nets, which are tied around the forehead and hang down the back of the dancer's head. The knotted fiber is edged with small feathers. Among the tribes of northwestern California, such as the Hupa, the accumulation of dance regalia plays a vital role in the culture both as an essential part of the dances and as a traditional indication of a person's wealth and virtue.

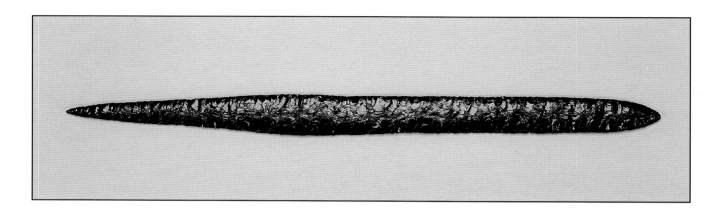

Blade
Hupa, ca. 1850
Obsidian
Length: 23"; Width: 1¾"
1026

To the Hupa and other people of northwestern California, large obsidian blades are items of prestige. Their value is determined by the purity of the obsidian, its color, and the workmanship of the blade. Dancers carry obsidian blades during the White Deerskin Dance. Traditionally, when the blades are not being used they are tied to a board, wrapped, placed in a carved wooden box, and then buried with a stone at the head and foot of the box.

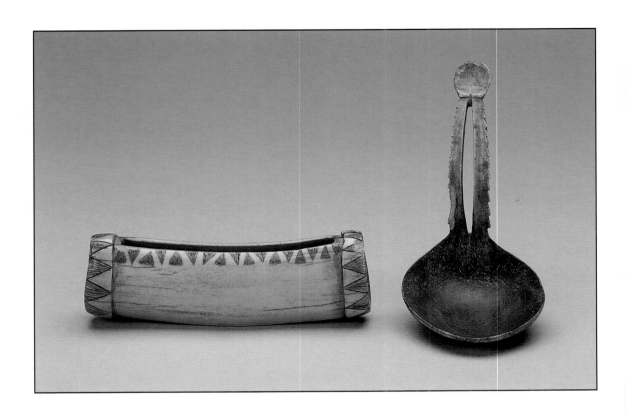

Purse
Yurok, ca. 1850
Elk antler
Length: 5¼"; Width: 1⅜"; Height: 1⅝"
87.88.72

Spoon
Klamath, ca. 1890
Elk antler
Length: 4½"; Width: 4½"; Height: 2¾"
240

Tribes such as the Yurok of northwestern California and the Klamath of southern Oregon carried on a lively tradition of carving items from both elk antlers and wood. Elk antlers were cut in sections to be fashioned into small containers for dentalia, a marine shell that was used as money by the Yurok and other tribes of northwestern California. Spoons were also frequently carved from elk antlers. Traditionally used as serving utensils at feasts, these intricately carved spoons reflect the wealth and prestige of the host.

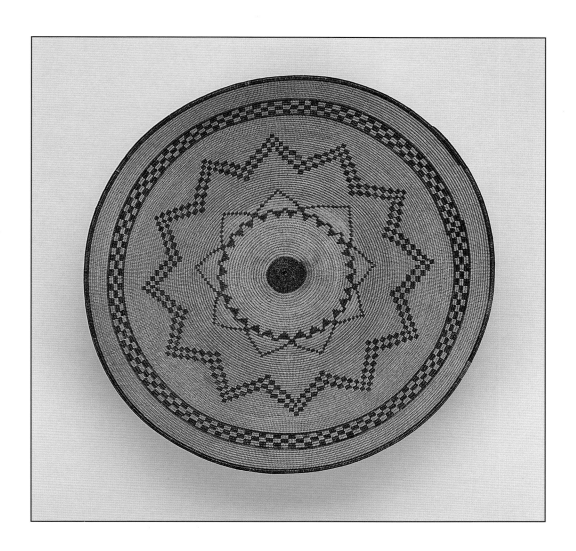

Basket
Chemehuevi, ca. 1920
Willow, devil's claw, yucca root
Height: 5"; Diameter: 16½"
91.95.48

Coiled, shallow bowls are the most characteristic form of Chemehuevi basketry. The designs are usually black (devil's claw) on the natural brown background (willow). Often the design is laid out concentrically, with frequent use of checks and stepped patterns.

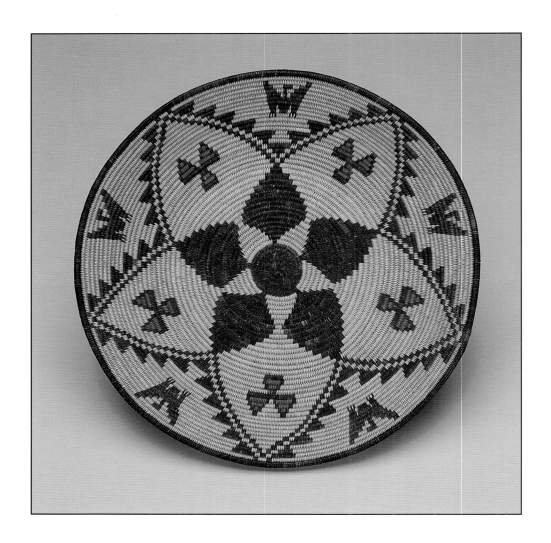

Basket
Yavapai, ca. 1920
Willow, devil's claw, yucca root
Height: 2¼"; Diameter: 13¼"
91.95.66

Yavapai baskets are usually coiled, and the most common forms are trays, shallow bowls, and plaques. The radiating designs and figurative elements used on Yavapai baskets are similar to those used by Western Apache basket makers, and these similarities make it difficult to distinguish between Yavapai and Western Apache baskets. Sometimes, however, the designs on Yavapai baskets appear to be more precise and more symmetrical than those on Apache baskets.

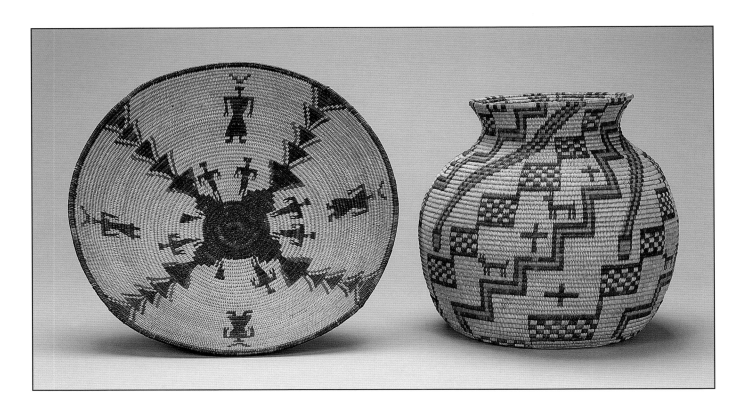

Basket
San Carlos Apache, ca. 1920
Willow, devil's claw, yucca root
Height: 3½"; Diameter: 15"
91.95.70

Basket
Western Apache, ca. 1920
Willow, devil's claw, yucca root
Height: 12"; Diameter: 10½"
1744

Western Apache includes the Cibecue, San Carlos, White Mountain, and Northern and Southern Tonto Apache groups who live in what is now Arizona. Many baskets from these peoples are simply identified as Western Apache, due to the difficulty of distinguishing between them stylistically. These peoples used twining exclusively when making large burden baskets. All other baskets, from shallow bowls to deep jars, are made by coiling. Coiled baskets are always decorated with boldly executed black designs against a white or tan background. The use of red—obtained from yucca root—as an accent color began after 1900 in an effort to increase the market value of the baskets to non-Native buyers. The most common type of design on bowls such as the one at left radiates from the center of the basket to the rim, often with figurative elements between the radiating lines. The design on the jar at right is typical of many Western Apache jars. It includes interlocking rectangles that form diagonals, interspersed with human and animal figures.

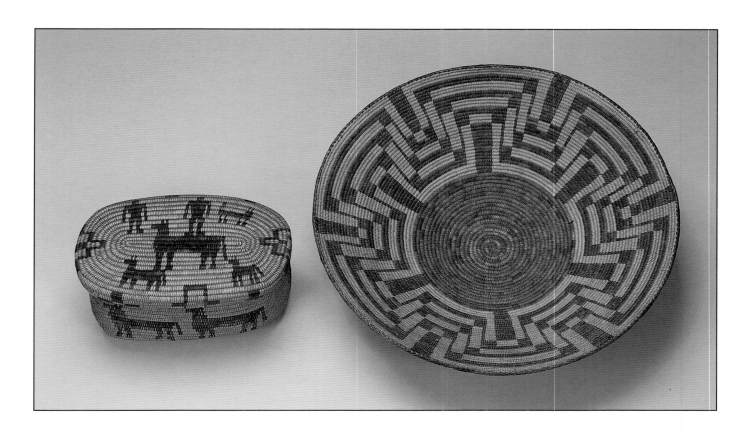

Lidded Basket
Pima, ca. 1920
Willow, devil's claw, cattail
Height: 5½"; Length: 13"; Width: 8½"
1699

Basket
Pima, ca. 1920
Willow, devil's claw, cattail
Height: 6"; Diameter: 22"
91.95.69

The most common form of Pima basket is a large shallow bowl. Traditionally, these baskets served a variety of purposes in the Pima household. The designs on these bowls are almost always geometric, frequently featuring lines radiating from the center of the basket toward the edge. The design on the bowl on the right is a six-pointed star-like motif referred to as "squash blossom." The small lidded basket, with its unusual form and figurative design elements, exemplifies the Pima baskets that were made after 1900 specifically to be sold.

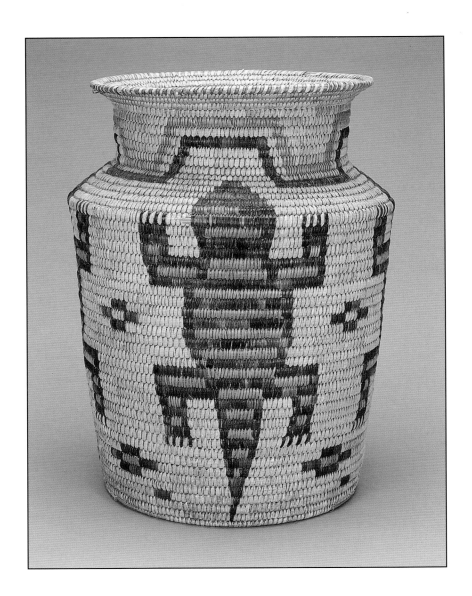

Basket
Tohono O'Odham, ca. 1920
Yucca, grass
Height: 18½"; Diameter: 14½"
751

This is an example of a specific type of basket that first developed around 1900 — possibly as early as the 1880s — as a result of the arrival of settlers and eastern visitors and their interest in collecting baskets. In response to this demand Tohono O'Odham basket makers began to use yucca instead of willow, which reduced the time and effort required to gather the materials and produce the baskets. These yucca baskets were made in a variety of shapes and sizes, including large jars with flat bottoms such as this one. Figurative designs, such as this gila monster, were also more frequently used, again as a response to market demand.

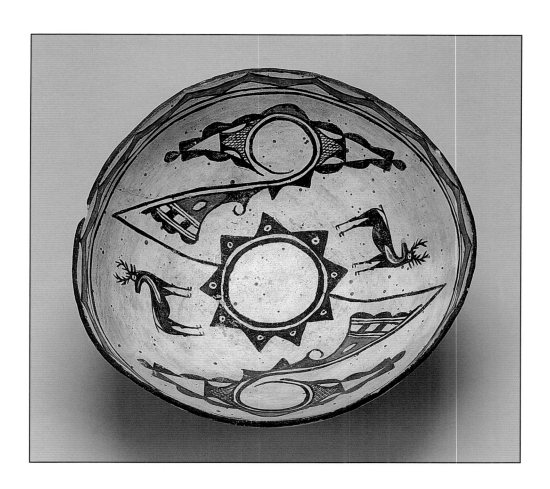

Bowl
Zuni, ca. 1920
Clay
Height: 5¼"; Diameter: 14⅞"
1818

Large pottery bowls such as this one were traditionally used by Pueblo peoples to mix dough for bread. Zuni pottery is typically decorated with polychrome designs painted on a white slip background. The deer with a heartline is a characteristic Zuni design, as are the spiral elements on the interior of this bowl.

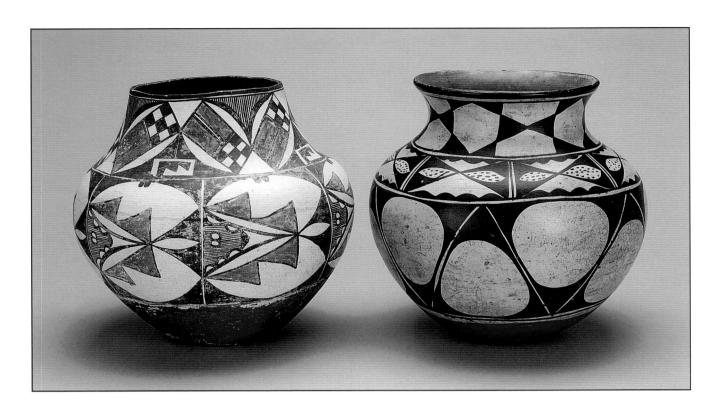

Jar
Acoma, ca. 1900
Clay
Height: 10"; Diameter: 10"
1406

Jar
Santo Domingo, ca. 1920
Clay
Height: 10 ¼"; Diameter: 10"
1481

Pueblo Indians in the Southwest began making pottery about 2,000 years ago. Styles of traditional pottery differ from pueblo to pueblo in terms of the clay, the shapes of the vessels, and the painted decoration. Traditional Acoma pottery, made from a white or gray clay, has as its most common form a high-shouldered jar with thin walls and a straight neck. The decoration is usually precisely painted with geometric designs in black, red, orange, and sometimes yellow on a white slip background. Traditional Santo Domingo pottery is made from a reddish clay. Santo Domingo jars tend to have a rounder shape and characteristically have a slightly flaring rim. The painted decoration is frequently black on a cream slip background with a positive-negative ambiguity in the design.

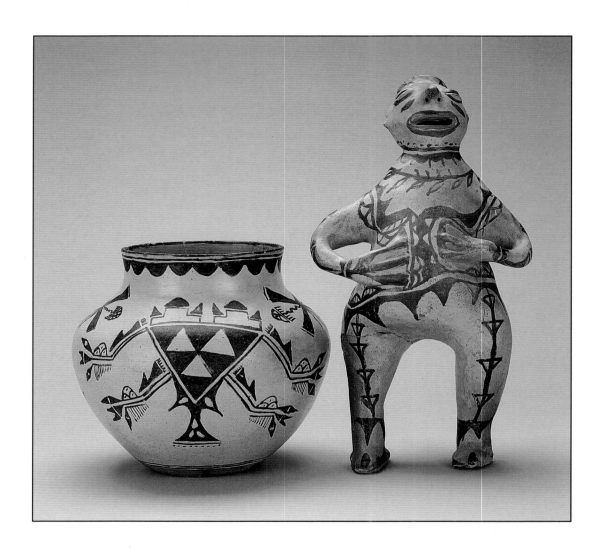

Jar
Cochiti, ca. 1930
Clay
Height: 9½"; Diameter: 10"
1717

Pottery Figure
Cochiti, ca. 1910
Clay
Height: 18"; Width: 9¼"; Depth: 7½"
91.95.22

Cochiti jars typically are made with a high shoulder and painted with iso-
lated black designs on a cream-colored slip. Standing pottery figures are
unique to the Cochiti. These figures, called monos, were made from ap-
proximately 1890 to 1915, although this tradition has recently been revived.
The majority of these figures represent non-Native American people satiri-
cally and reflect the wry observations of Pueblo people about non-Native
American culture. This example typifies Cochiti figures, with loosely paint-
ed designs and an expression of laughter.

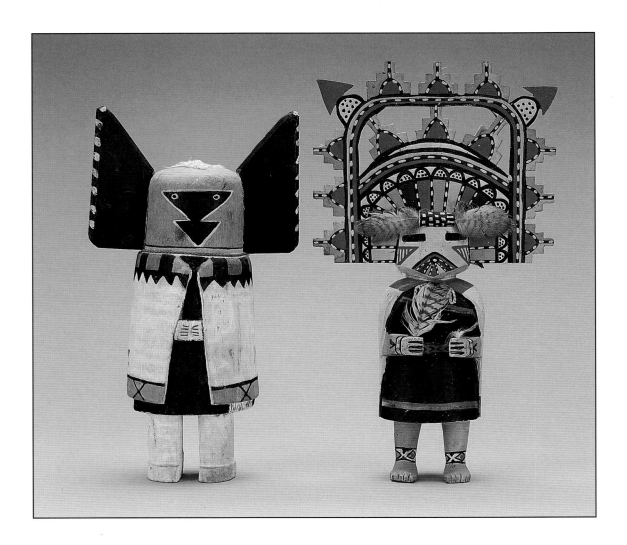

Kachina Carving (Crow Mother)
Hopi, ca. 1940–1950
Cottonwood, paint
Height: 14 ⅜"; Width: 7 ½"; Depth: 4 ¼"
607

Kachina Carving (Polik Mana)
Hopi, ca. 1940
Cottonwood, paint, feathers
Height: 16 ½"; Width: 9 ⅛"; Depth: 2 ¾"
592

The Hopi and other Pueblo peoples carve figures to represent the Kachinas, supernatural beings responsible for carrying the prayers of the people to the heavens. The figures are traditionally carved out of cottonwood root and then painted with the specific characteristics of one of the many different Kachina spirits. The carvings serve as a constant reminder of the spiritual aspect of Pueblo life. They have become valuable as collector's items, which has resulted in increasingly elaborate figures carved specifically for the marketplace.

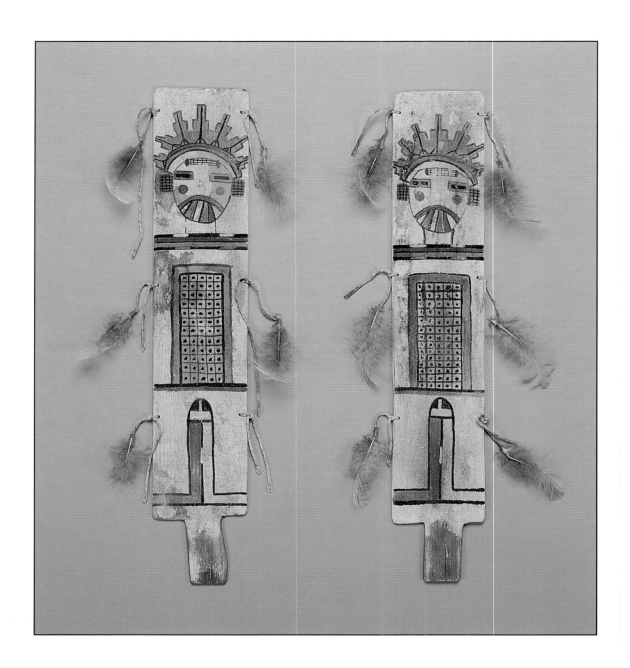

Dance Wands
Hopi, ca. 1880–1900
Cottonwood, paint, feathers, string
Length: 20"; Width: 3 ¼
817a and 817b

These wands would have been carried by a dancer in one of the various dances of the Hopi ceremonial calendar. Carved from cottonwood, they are painted to represent a kachina on one side, with clouds and rainbows painted on the reverse, possibly as a prayer for rain.

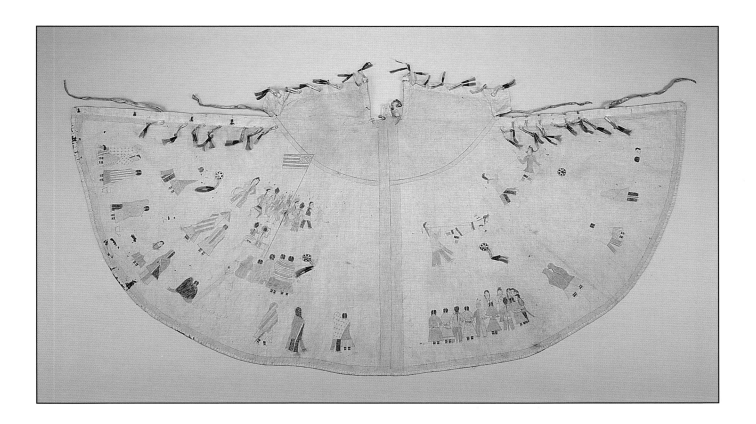

Model Tipi Cover
Cheyenne, ca. 1890–1900
Muslin, ink, leather ties, metal cones, dyed horsehair, glass beads
Length: 66"; Width: 33½"
86.126.5

Plains Indian peoples traditionally used figurative painting to decorate a variety of objects. The painting was most often done by men, and it reflects their activities. Many paintings are narrative and refer to a person's exploits; other paintings are quite personal and are associated with the protective medicine received in visions. By the last quarter of the nineteenth century, genre scenes of Plains Indian life became the subject of many paintings, such as the one on this model tipi cover. On one side it depicts a man's dance, with female spectators and two singers seated by a flagpole; several couples have blankets drawn around them in traditional courting fashion. On the other side are several people fighting, along with a social dance and more courting couples.

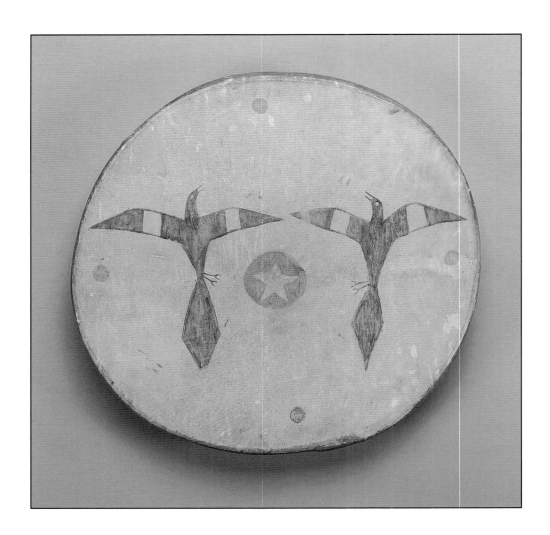

Hand Drum
Attributed to Chas. Kills Enemy
Lakota, ca. 1900
Rawhide, wooden frame, paint
Diameter: 16¾"; Height: 2¾"
85.113.4

Small drums that could be held in one hand were used throughout the Plains region. They were created by stretching rawhide over a round wooden form. Taut rawhide thongs cross on the underside and act as a handle. The rawhide head of the drum is frequently painted with imagery that would have had special meaning to the owner. The magpies and star on this drum may refer to the Ghost Dance, while the green circles may refer to the four directions. The inside of the wooden form is signed "Chas. Kills Enemy." It is rare for Plains Indian art to be signed, so this may indicate that Chas. Kills Enemy was a well-known drum maker, or that this drum once belonged to him.

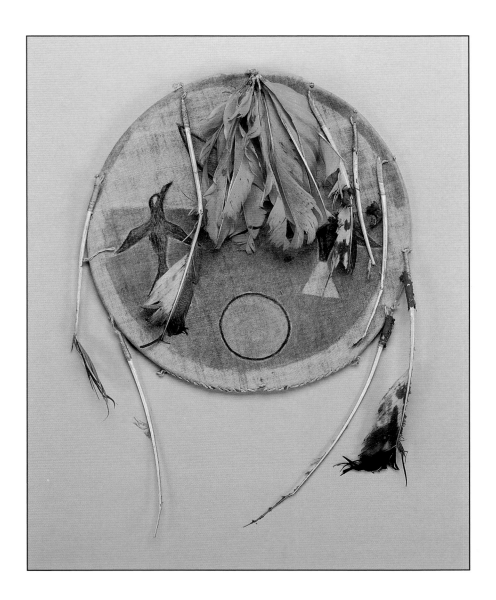

Dance Shield
Lakota, ca. 1890
Rawhide, muslin, wool cloth, paint, feathers
Diameter: 11½"
86.126.39

Shields continued to be made because of their spiritually protective proper-
ties even after the introduction of firearms had diminished their usefulness
as physical protection. The painted designs and feather adornments all re-
lated to an individual's visions. Smaller shields carried in dances indicated
that the owner had been successful in receiving spiritual protection. The im-
ages on this muslin painting of two birds, a crescent, and a circle would have
been familiar to most Lakota people at that time, although their exact mean-
ing would have been known only to the person who had received the vision.
The feathers attached to the edges would have swayed as the person danced,
first obscuring and then revealing the images.

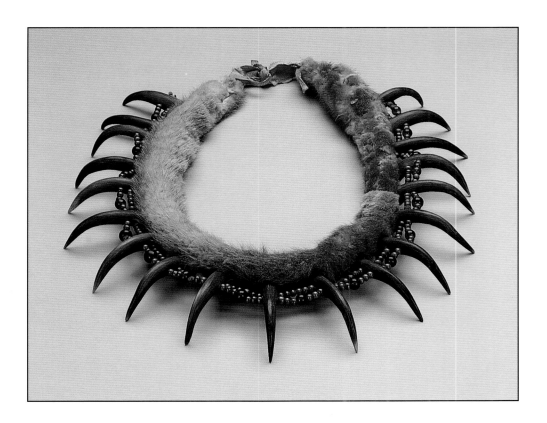

Necklace
Plains, ca. 1860–1880
Claws carved from antelope horn, otter fur, metal beads, glass beads, leather ties
Length: 18"; Width: 15½"
89.52.11

Men who had hunted enough grizzly bears to make a bear claw necklace earned the right to own and wear this prestigious item. The claws are usually mounted on a foundation of otter fur and separated with large trade beads. The claws on this particular necklace are actually carved from antelope horn, probably because of the scarcity of grizzly bears on the Plains by the mid-nineteenth century.

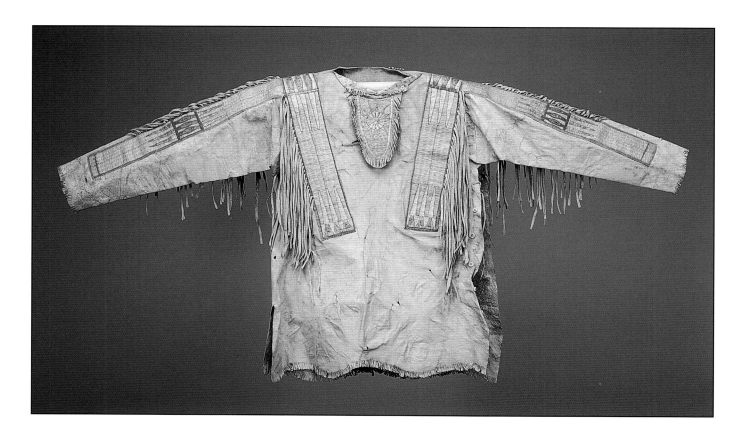

Shirt (rear view)
Blackfeet, ca. 1900
Leather, porcupine quills, buttons
Length: 30"; Width: 59"
86.126.32

Plains Indian men had to earn by their actions the right to wear an elaborately decorated shirt. Although the exact style of shirts varies from tribe to tribe, they are usually long sleeved, with open sides and a long, generous cut. Many Blackfeet shirts, such as this one, are decorated with porcupine quills that are flattened, dyed, and then sewn onto leather strips on the back of each sleeve, over each shoulder, and on the flaps on the front and back of the neck. The shirt is also adorned with leather fringe. The open side has button closures.

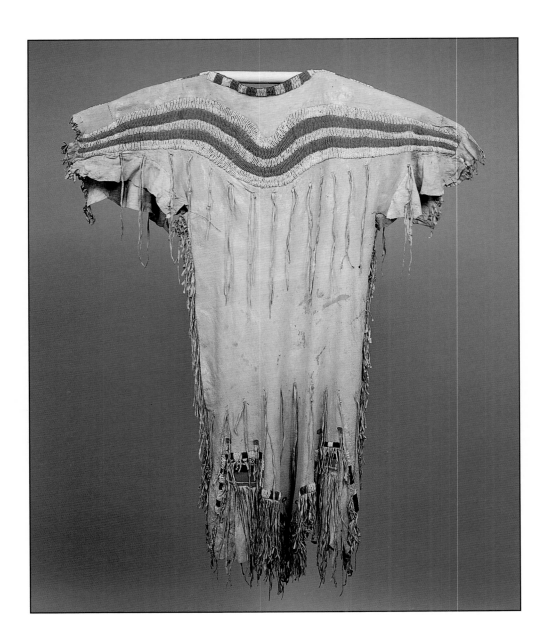

Dress
Blackfeet, ca. 1890
Leather, glass beads, wool cloth
Length: 55"; Width: 50"
87.88.115

Blackfeet dresses, like those of other peoples of the northern Plains, are traditionally made from the skins of two deer or antelope. The tanned skins are sewn together with the head down, so that the rear legs form the sleeves. On some Blackfeet dresses the tail was left on the skin and allowed to fold down below the neckline on the front and back; the dip in the center of the beadwork across the shoulders of this dress recalls that style, although the tails were cut off these skins. The horizontal rows of beadwork are characteristic of many Blackfeet dresses, as are the decorative cloth patches near the hem.

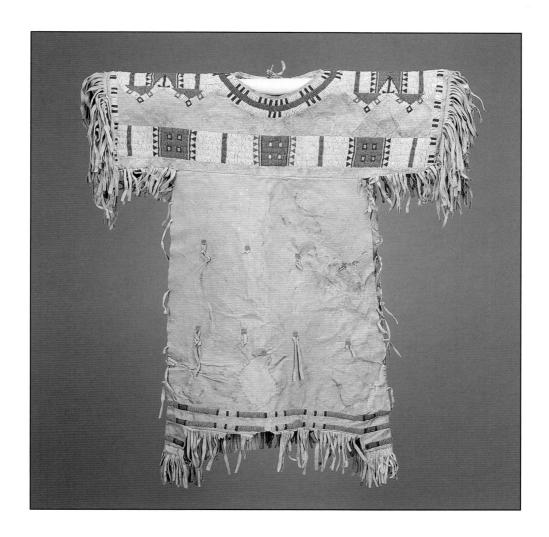

Girl's Dress
Cheyenne, ca. 1890
Leather, glass beads
Length: 28"; Width: 24"
87.70.22

The basic pattern for Cheyenne dresses and those made by other tribes of the central Plains used one skin for the bodice, one for the front of the skirt, and one for the back of the skirt. The dress would be cut square and fringed on the sleeves and at the hem, with large areas often covered with yellow or green pigment. Three strips of beads decorate this dress: one across the front, another across the back, and a third along the top of the shoulders. Typical Cheyenne beaded designs on dresses include boxes with pendant triangles on a white background.

Elk Tooth Dress
Crow, ca. 1890
Wool cloth, elk teeth, carved bone, glass beads
Length: 47"; Width: 54¾"
87.88.90

By the late nineteenth century, it was common for Plains Indians to use wool cloth instead of skins to make dresses. Crow dresses are characteristically styled with tapered, closed sleeves. A band of constrasting colored cloth is sewn around the hem, wrists, and neck. This dress is adorned with elk teeth in rows around the upper portion of the dress and sleeves. Since a mature elk has only two of these vestigial teeth, it would have taken many years to amass enough of them to decorate a dress in this manner. Such dresses therefore became symbols of wealth and reflected the hunting prowess of the woman's male relatives. Because of the difficulty of collecting so many elk teeth, many men carved bone copies to use in combination with real teeth.

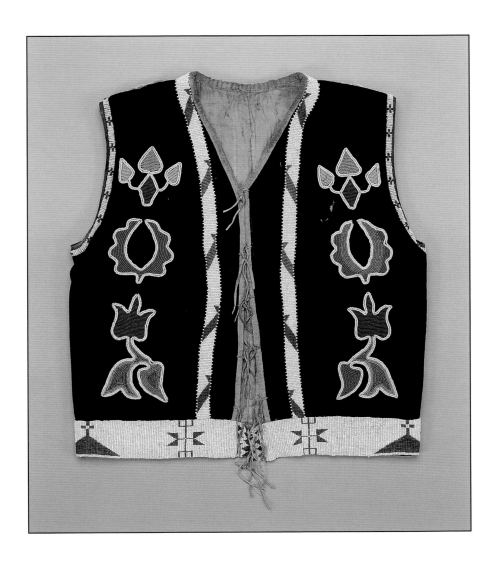

Vest
Osage, ca. 1900
Wool cloth, cotton cloth lining, glass beads, leather ties
Length: 23"; Width: 18"
344

Vests were a common item of men's clothing on the Plains by the end of the nineteenth century. Men wore these highly decorated vests on special occasions when it was important for them to look their best. The Osage and other tribes on the eastern Plains—or Prairie—region, often beaded items with abstract floral designs. The isolated designs often bear no direct connection between each element, and there is no beaded background. This vest features floral designs on the back as well as the front. They are complemented by loom-beaded strips bearing geometric designs around the hem and up the front, with an additional row of beadwork around the arm openings.

Boy's Vest
Dakota, ca. 1880-1900
Leather, porcupine quills
Length: 14½"; Width: 14¾"
1573a

The Dakota are the eastern Sioux groups who historically lived on the edge of the Plains in the region that now includes the states of Minnesota and Iowa. Many of their garments were traditionally decorated with porcupine quill embroidery, such as that which ornaments this boy's vest on both the front and the back. A matching set of leather trousers completed the outfit. The floral and bird designs are typical of the increased use of representational beadwork and quillwork designs by Plains artists toward the end of the nineteenth century.

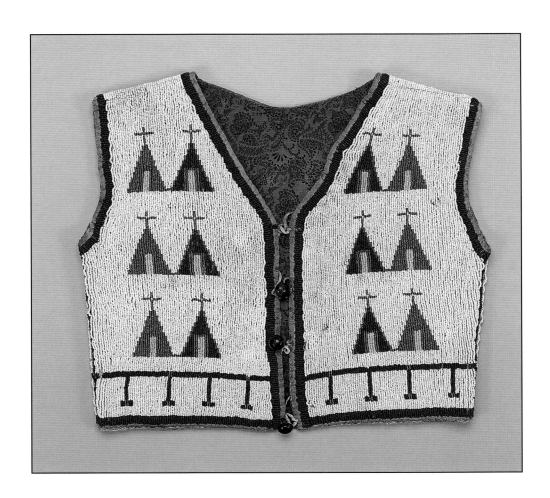

Boy's Vest
Lakota, ca. 1900
Leather, cotton cloth, glass beads
Length: 13"; Width: 15½"
339

Confined to a sedentary life on the reservation by the late nineteenth century, Lakota women began to decorate objects with more and more beadwork and increasingly elaborate designs. A woman was considered virtuous if her family was dressed in fine clothing. This boy's vest, for example, is fully beaded on the front and back. The designs, typically Lakota, are geometric and laid out symmetrically. The narrow range of colors, primarily red, blue, green, and yellow on a white background, characterizes Lakota beadwork.

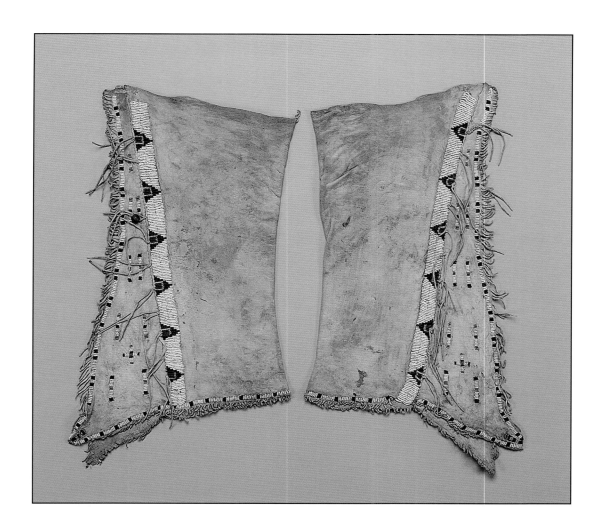

Boy's Leggings
Cheyenne, ca. 1890–1900
Leather, paint, glass beads
Length: 15 ½"; Width: 9"
125a and 125b

Clothes for Plains Indian children are traditionally made with the same care and decorated in the same manner as adult clothing. Typical of Cheyenne men's leggings, this smaller pair extended from the hip to the ankle. They were held up by a belt worn around the waist and passing through loops at the top of each legging. The leather surface is covered with yellow paint—a common trait among the Cheyenne and other tribes of the southern Plains. A beaded strip runs down the side and around the bottom of each legging. The wide triangular flaps bear additional beadwork and fringe.

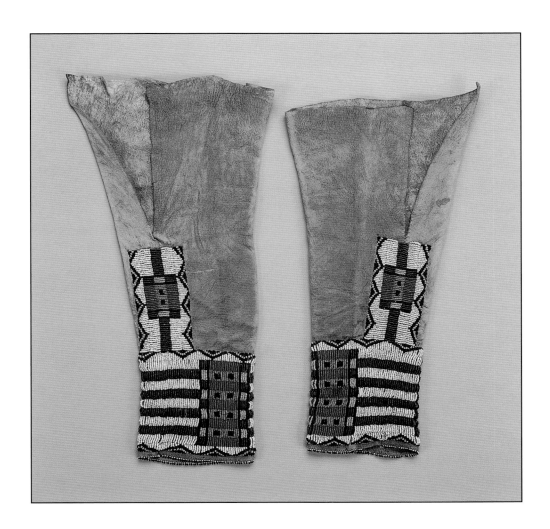

Girl's Leggings
Cheyenne, ca. 1890
Leather, paint, glass beads
Length: 14"; Width: 6¼"
127a and 127b

In contrast to boy's and men's leggings, traditional leggings for Cheyenne girls and women extended only from just below the knee to the ankle, thus covering the area below the knees not otherwise covered by a dress. The leggings were secured with ties, and the excess flap at the top was turned down. The usual decoration is a wide band of beadwork around the ankle, with another vertical band covering the seam. In Cheyenne fashion, alternating bars of color are juxtaposed with a rectangular box containing a different alternating pattern.

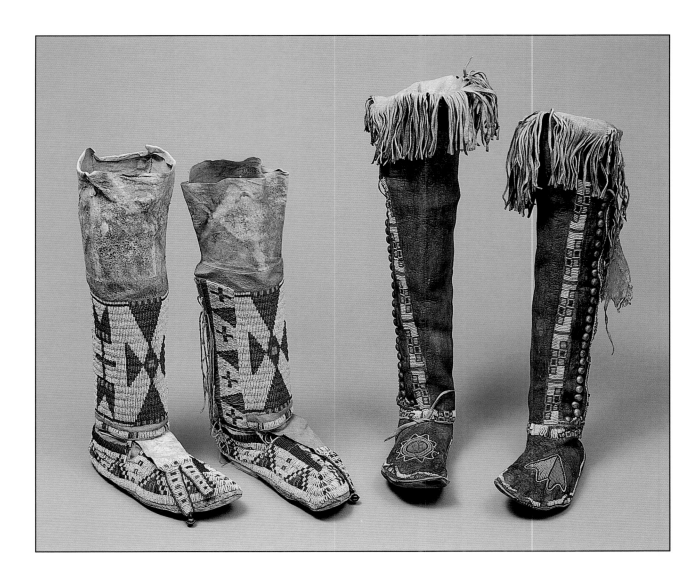

Moccasins and Leggings
Lakota, ca. 1890–1900
Leather, rawhide, glass beads, brass bells
Height: 13½"; Length: 10¾"; Width: 3¾"
87.88.150a and 87.88.150b

Boots
Kiowa, ca. 1890–1900
Leather, paint, rawhide, glass beads, metal studs
Height: 23"; Length: 9"; Width: 3½"
87.88.57a and 87.88.57b

Traditional footwear for Plains Indian women is usually either boots or a combination of moccasins and leggings. Lakota women commonly wore the latter. The moccasins are characteristically made with a hard rawhide sole and a bifurcated tongue; these are often extensively decorated with lazy stitch beadwork in geometric designs on a white background. Leggings offered additional protection and a sense of modesty. In contrast to Lakota women, many Kiowa women traditionally wear knee-high boots, decorated with much less beadwork than the Lakota moccasins and employing a different approach to color. Kiowa beadwork commonly uses different beaded designs on each toe, and the boots are further ornamented by metal studs and by paint on the unbeaded surface.

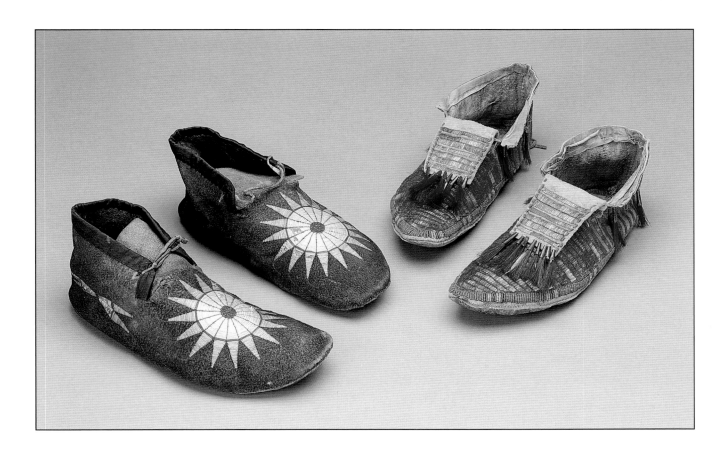

Moccasins
Mandan, ca. 1850–1870
Buffalo hide, porcupine quills,
　cotton cloth
Length: 10¾"; Width: 4"; Height: 4½"
91.95.2a and 91.95.2b

Moccasins
Plains (possibly Cheyenne), ca. 1890–1900
Leather, rawhide, glass beads, porcupine quills,
　metal cones, dyed horsehair, cotton cloth binding
Length: 10½"; Width: 4¼"; Height: 3½"
87.88.39a and 87.88.39b

Plains Indian people traditionally used porcupine quills to decorate clothing and other items. As glass beads introduced by traders became more and more available, the use of porcupine quills gradually declined, though it never stopped completely. The embroidered design of porcupine quills on the pair of moccasins on the left is unique to the Mandan; it usually consists of a sectioned circle with pendant triangles, sometimes referred to as "sunburst." It is similar to the quilled and painted designs found on buffalo hide robes of the same period.

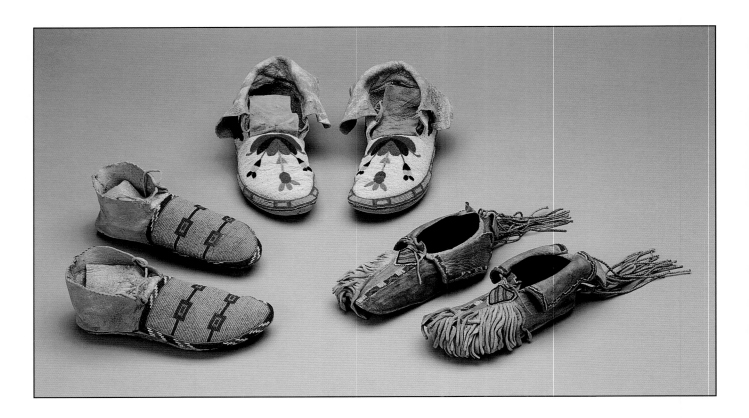

Moccasins
Crow, ca. 1920–1940
Leather, rawhide, glass beads
Length: 9¾"; Width: 3½";
 Height: 3½"
89.52.49a and 89.52.49b

Moccasins
Blackfeet, ca. 1890
Leather, rawhide, glass beads
Length: 10¼"; Width: 4½";
 Height: 4¼"
1425a and 1425b

Moccasins
Kiowa, ca. 1890–1900
Leather, paint, rawhide, glass beads
Length: 9½"; Width: 3"; Height:
 3" (excluding fringe)
1629a and 1629b

Most Plains Indian moccasins are constructed with a hard rawhide sole sewn onto tanned leather uppers. There are many different styles, however, within the basic pattern. For example, the pair of Crow moccasins on the left are low cut with a unique beaded decoration entirely on the toe. The Blackfeet moccasins, center, are cut higher with an ankle flap and are fully beaded with an abstract floral design. The Kiowa moccasins on the right are low cut with an ankle flap and an abundance of fringe on the toe; they are sparsely beaded, and the unbeaded surface is covered with green and red paint. The fringe at the heel is commonly thought to have obscured the wearer's tracks. It is more likely, however, that the fringe is simply a decorative device that would have swayed to and fro when the wearer was on horseback.

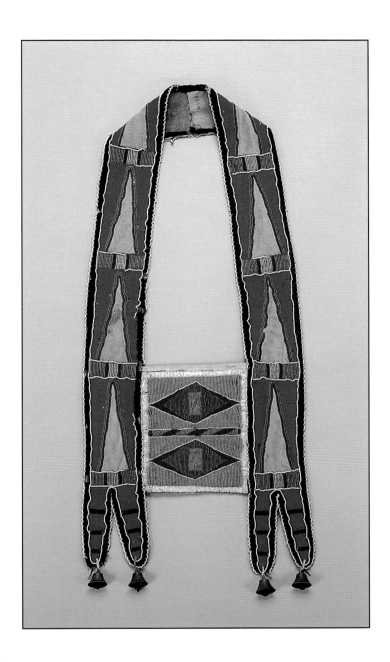

Bandolier Bag
Crow, ca. 1880–1900
Wool cloth, glass beads, leather, brass bells
Length: 33"; Width: 14"
87.88.16

Bandolier bags, sometimes also called shoulder bags, were frequently worn by Plains Indian men to carry necessities such as food and ammunition. Elaborately decorated bags such as this one were worn on special occasions. The elongated triangles and diamond motifs are typical of Crow beadwork, as is the integration of red wool cloth as an essential part of the design. The small brass bells at the bottom tabs add sound to the overall effect.

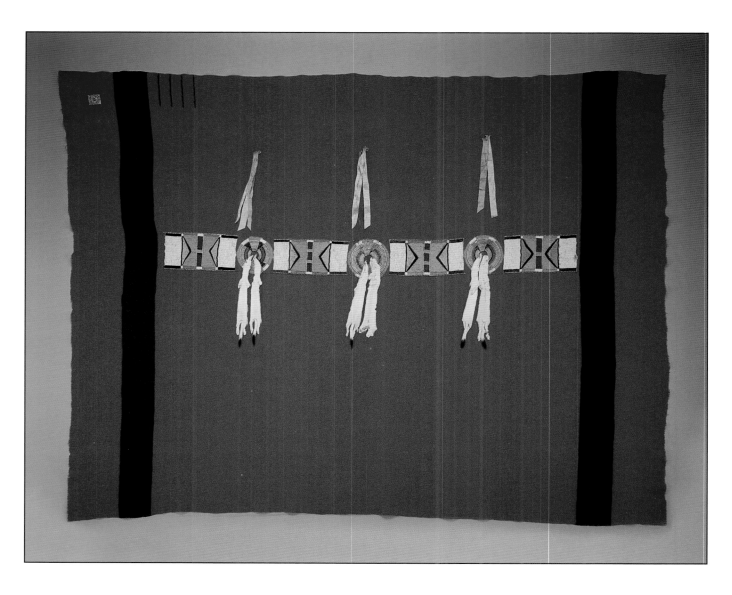

Blanket
Crow, ca. 1890
Wool cloth, leather, glass beads, porcupine quills, horsehair, silk ribbon, ermine skins
Length: 67"; Width: 90"
90.33.7

Crow Indian beadwork is quite different from the beadwork of other Plains Indian peoples. The beadwork on this blanket strip illustrates the color combinations, such as light blue and pink, used to form the triangular and hourglass designs characteristic of Crow beadwork. The rosettes on this strip are also noteworthy: they are made of quill-wrapped horsehair. In this rarely used technique, small bundles of horsehair spiral out from the center to form the rosette. As the bundles are sewn onto the blanket strip, they are wrapped with dyed porcupine quills. On this blanket the artist used ribbons and ermine skins as additional ornamentation.

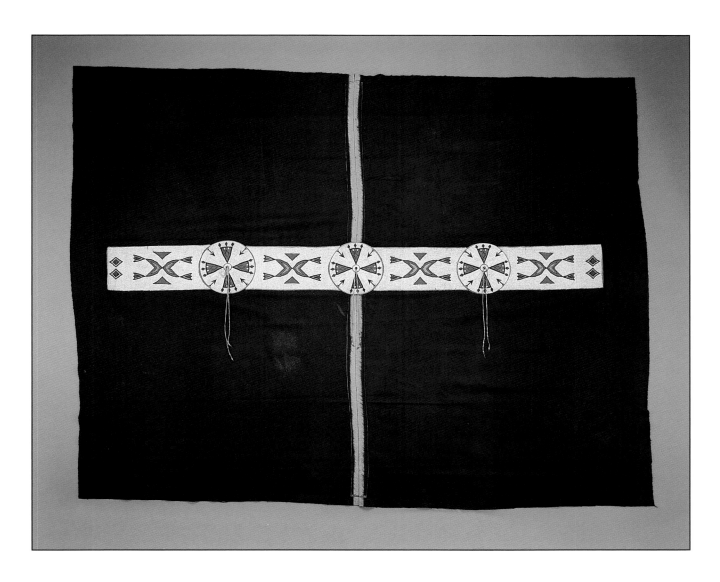

Blanket
Blackfeet, ca. 1890
Wool cloth, glass beads, leather
Length: 58 ½"; Width: 74 ½"
226

Wool blankets were a common trade item on the Plains during the nine-
teenth century. In some cases the blankets were fashioned into articles of
clothing such as shirts, dresses, and leggings. In other instances the blankets
were left whole or pieced together to be used as outerwear. This blanket is
decorated with a strip that is characteristic of Blackfeet beadwork at the end
of the nineteenth century.

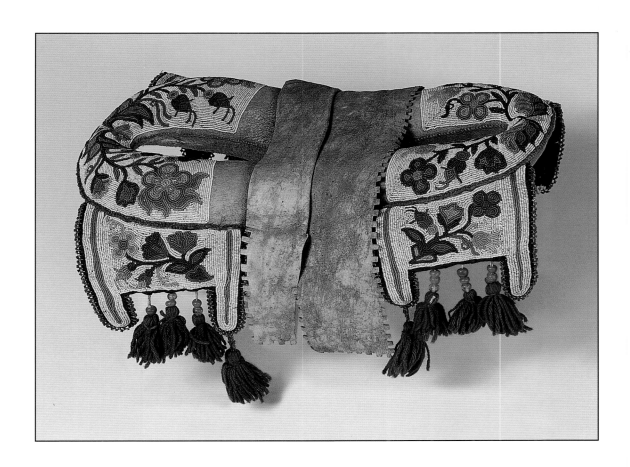

Pad Saddle
Plains Cree, ca. 1890
Leather, glass beads, wool yarn
Length: 16½"; Width: 8¾"; Height: 6"
91.95.21

By the mid-eighteenth century horses had spread throughout the Plains region. As Plains Indian peoples became expert horsemen, they began to create a variety of trappings for their horses. Derived from Spanish pack saddles, pad saddles were commonly made by peoples of the northern and northeastern Plains such as the Plains Cree. Pad saddles are usually rectangular or oval tanned leather tubes stuffed with grass or moose hair. A band of tanned leather sewn across the middle provides an attachment for the stirrups. Floral beaded decoration covers the corners, from which hang beaded panels that are often further embellished with yarn tassels.

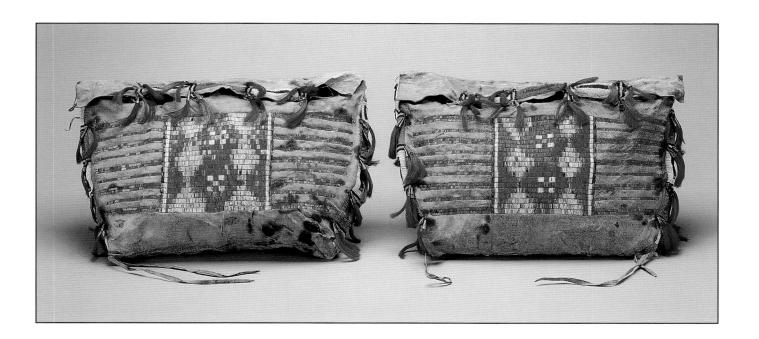

Storage Bags
Lakota, ca. 1890
Leather, porcupine quills, glass beads, metal cones, dyed horsehair
Length: 14"; Width: 24"
87.88.95a and 87.88.95b

After the introduction of horses, Plains Indian peoples became much more mobile. Horses allowed them to stay on the move, following the buffalo herds. By necessity, everything families owned had to be portable; they needed a variety of containers to pack belongings when the camp was moved. This pair of Lakota storage bags might have been mounted on saddle bags and would have held anything from clothing to food. They are made from tanned leather and decorated with porcupine quill embroidery across the front, with a beaded strip along each side and across the top flap. Tin cones and dyed horsehair futher accent the beaded strips.

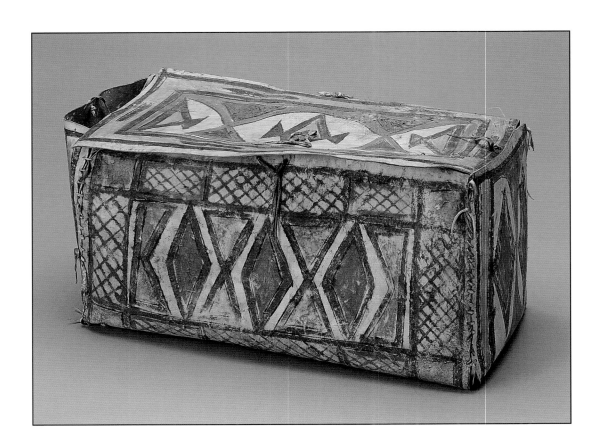

Rawhide Box
Lakota, ca. 1890
Rawhide, paint, leather ties
Length: 22"; Width: 14"; Height: 14"
89.52.7

Plains Indian people frequently made lightweight rawhide containers to hold a variety of objects. Flat envelopes and cylinders were the most common shapes, although the Lakota frequently made boxes. As part of their household duties, women laboriously made and decorated these containers from buffalo hide or cowhide that had been dried and scraped of its hair. Once the rawhide was processed, it was cut into a predetermined pattern and then folded and laced into shape. Painted geometric designs usually ornament the rawhide containers.

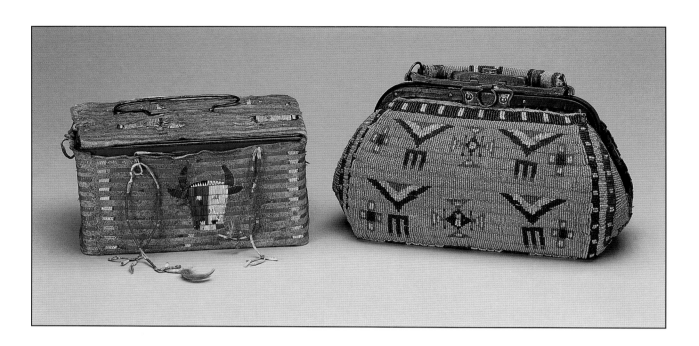

Tin Box
Plains, ca. 1890–1900
Tin, leather, porcupine quills
Length: 8½"; Width: 5½"; Height: 4¾"
100

Doctor's Bag
Cheyenne, ca. 1880–1900
Commercial leather, glass beads, metal trim
Length: 10¾"; Width: 5¼"; Height: 6"
89.52.10

As Plains Indian peoples were confined to reservations in the late nineteenth century, women artists, who created the majority of beadwork and quillwork, began to apply their skills to a wider variety of objects. The tin box at left is covered with tanned leather and then decorated with porcupine quill embroidery. Buffalo heads are a common motif on Plains Indian art of that era. The fully beaded doctor's bag illustrates how beadworkers were able to take commercially made objects and turn them into uniquely Native American artistic expressions.

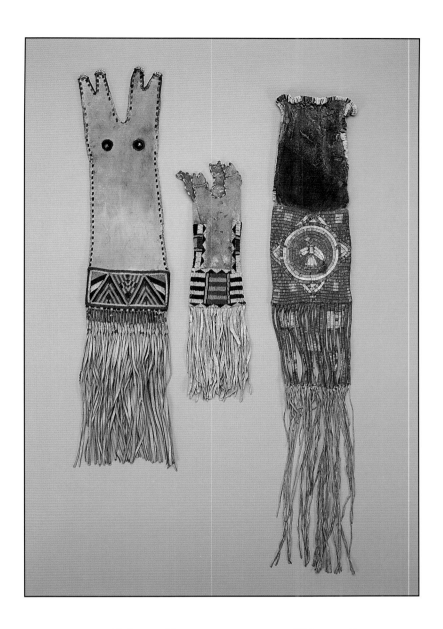

Tobacco Bag
Plains Cree, ca. 1890
Leather, glass beads,
 porcupine quills
Length: 29"; Width: 5½"
1674

Tobacco Bag
Cheyenne, ca. 1890
Leather, glass beads
Length: 17½"; Width: 4"
1156

Tobacco Bag
Lakota, ca. 1900
Leather, porcupine quills, glass beads,
 paint, metal cones, dyed horsehair
Length: 36"; Width: 6"
87.88.5

In addition to being useful containers, tobacco bags were worn as clothing accessories by Plains Indian men. They were carried in the hand, with the body of the bag and the fringe allowed to hang freely. These bags were made from tanned leather, cut and sewn into a rectangular shape with an opening at the top. The decoration, either beaded or quilled, is usually made up of a rectangular or square panel at the bottom of the bag, with additional beadwork in strips or as accents extending up the sides and around the top. The designs frequently differ from one side to the other.

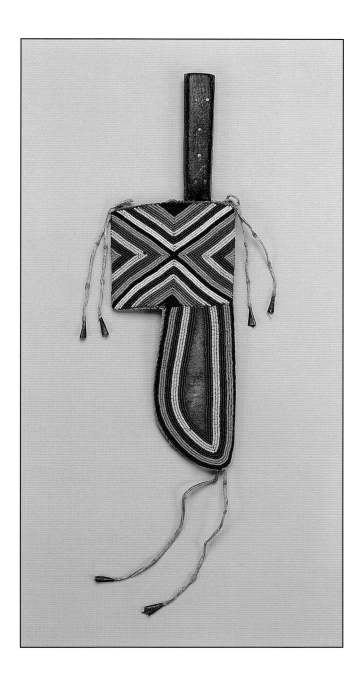

Knife and Case
Assiniboine, ca. 1880
Metal, wood, rawhide, glass beads, leather fringe, tin cones
Length: 14½"; Width: 4⅜"
119a and 119b

Steel knives were especially useful tools for Plains Indian peoples. Although they were not usually decorated, the cases used to hold them quite often were. This knife and case would have been worn on a belt. The case is constructed of thick rawhide decorated with beadwork, leather fringe, and tin cones. The striking design and use of color is characteristic of Assiniboine beadwork.

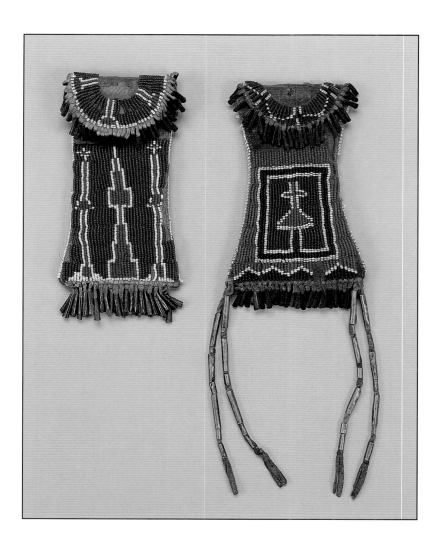

Pouch
Kiowa, ca. 1880–1900
Commercial leather, glass beads,
 tin cones
Length: 6"; Width: 2 ½"
178

Pouch
Kiowa, ca. 1880–1900
Commercial leather, glass beads,
 tin cones
Length: 10"; Width: 3 ½"
179

Kiowa women traditionally wore a number of distinctive bags and pouches on their belt to hold essential tools. These are often referred to as a belt set, generally containing a strike-a-light case, an awl case, and a whetstone case. These two strike-a-light cases are typical of Kiowa belt set pouches. Made from commercial leather, they have a rectangular or hourglass shape with a circular flap at the top. The items in a belt set are among the few Kiowa objects in which the surface is mostly or fully beaded. Vertically oriented or stacked geometric elements of beadwork are outlined in white against a deep, rich background such as dark blue or cranberry. The majority of these pouches are also adorned with small tin cones sewn along the bottom edge and flap. Longer fringe sometimes hangs from the bottom corners.

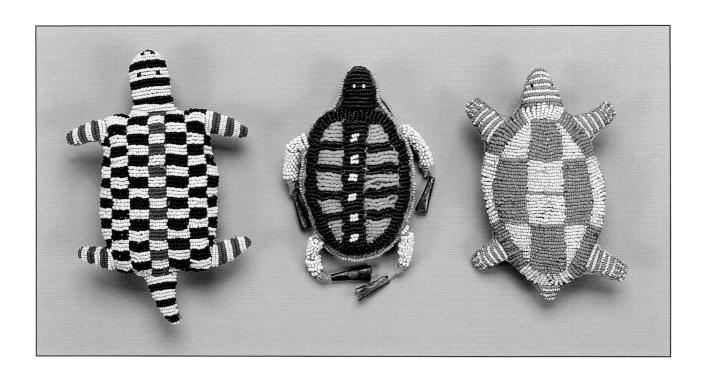

Turtle Amulet
Plains, ca. 1880–1900
Leather, glass beads
Length: 5"; Width: 3½"
916

Turtle Amulet
Plains, ca. 1880–1900
Leather, glass beads, tin cones
Length: 5"; Width: 3½"
913

Turtle Amulet
Plains, ca. 1880–1900
Leather, glass beads
Length: 5"; Width: 3½"
911

Plains Indians often made beaded amulets, frequently in the form of turtles or lizards, to coincide with the birth of a child. The amulets are made of tanned leather, which is sewn together and then stuffed. Although it is commonly believed that amulets contain the newborn's umbilical cord, this is not always true. The amulet would be attached to the baby's cradle, and when the child outgrew the cradle the amulet would be saved as a keepsake.

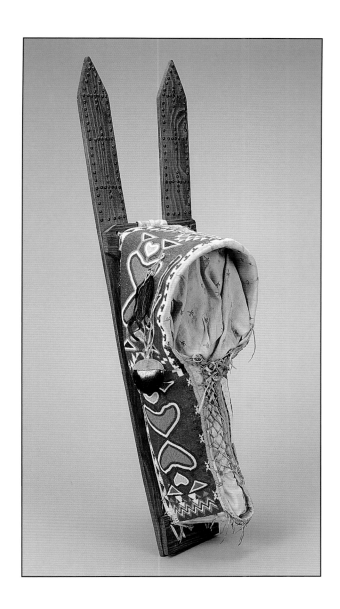

Cradle
Kiowa, ca. 1890
Wood frame, metal tacks, tanned leather, cotton cloth lining, glass beads, metal
 beads, leather ties, gourd, hair
Length: 43"; Width: 10½"; Depth: 10"
87.70.9

Among the Kiowa it was traditional for a female relative to construct a lattice cradle such as this one for the newborn as a token of affection. Two wooden crosspieces secure the bag at the head and foot to a pointed-stick framework adorned with metal tacks. The bag is made of tanned leather with a cotton cloth lining and is laced up the front with leather thongs to secure the child. Kiowa cradles are usually fully beaded in bold abstract floral designs thought to represent oak, maple, and sumac leaves. The designs on many Kiowa cradles are asymmetrical; on this one they are different on each side, and the background color shifts from red to white.

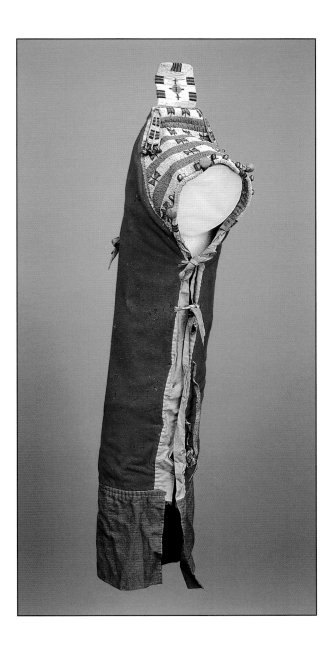

Cradle
Cheyenne, ca. 1900
Wood frame, wool cloth, cotton cloth, glass beads, leather ties, metal bells
Length: 57"; Width: 10"; Depth: 9"
87.70.11

This Cheyenne cradle is an example of the style made by many central Plains tribes. The framework is a single wooden stick bent into a U shape. The wool cloth bag fits like a sleeve over the frame and is secured in the front by several ties. The decoration, either beadwork or quillwork on this style of cradle, is limited to the hood. The beadwork on this cradle uses typical Cheyenne designs, featuring alternating bands of color with horizontal hourglass motifs in the white bands.

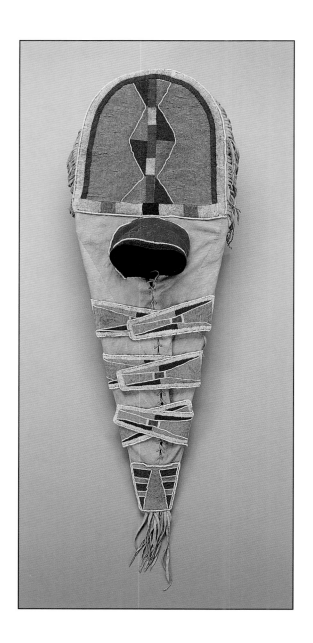

Cradle
Crow, ca. 1900–1920
Wood frame, leather, wool cloth, glass beads
Length: 37½"; Width: 12¼"; Depth: 6"
90.33.6

Crow cradles are distinctive in comparison with the cradles made by other
Plains Indian groups. They are made of a U-shaped solid wooden frame with
tanned leather stretched over it. A wool cloth covers the head, and the baby
is secured by a series of wide straps laced together up the front. Leather fringe
often hangs from the top and bottom edges. The large round area above the
hood is usually fully beaded. On this cradle the central hourglass design and
the color combination is typical of Crow geometric beadwork, as is the bead-
work on the straps and at the foot.

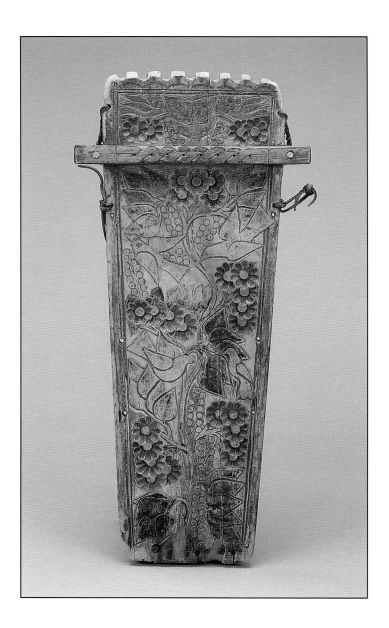

Cradle (rear view)
Iroquois, ca. 1830–1850
Wood, paint, leather ties
Length: 30"; Width: 13 ⅝"
87.70.13

Traditional Iroquois cradles have a wooden backboard decorated with elaborate relief carving that fills up nearly the entire back surface. The designs are remarkably similar from cradle to cradle. They usually consist of floral elements with vines, branches, and flowers in combination with dove-like birds. Once the carving was completed, paint would be applied to emphasize the design. The source of these designs was probably French Canadian folk art, reinterpreted by the Iroquois for their own use.

Canoe Model
Mohawk, ca. 1800
Wood
Length: 34½"; Width: 4¼"
87.70.25

The Mohawk and other members of the Iroquois Confederacy were expert sailors who used the inland waterways of the Great Lakes region as their highways. This model canoe recalls that expertise and provides an example of their woodworking artistry. The canoe is carved from a single piece of wood, with separate pieces for the cross-members. The two figures are also carved separately and sit in the canoe on pegs. Canoe models such as this could have been made for a child or specifically to be sold to settlers or visitors as an example of Mohawk culture.

Knife
Iroquois, ca. 1800
Wood, metal
Length: 10¼"; Width: 1⅝"; Height: 2"
1306

Woodworking, a traditional Iroquois artistic expression, prospered with the introduction of metal tools. This knife illustrates both the type of tools used and the results of those efforts. The small steel blade set at an angle would have been used for detail work on difficult areas. It is set into a wooden handle gracefully carved into the shape of a hand. The use of a hand as a handle is a visual pun that can be appreciated for both its humor and its artistry.

Female Doll
Huron, ca. 1830–1850
Wood, wool cloth, cotton cloth,
 metal, glass beads, leather, hair
Height: 14¾"; Width: 6"; Depth 2½"
88.43.6

Male Doll
Huron, ca. 1830–1850
Wood, wool cloth, cotton cloth,
 metal, glass beads, leather, hair
Height: 15"; Width: 5½"; Depth: 2½"
88.43.7

In most Native American societies dolls were often quite detailed, providing children with examples of tribal customs and appropriate modes of behavior. In addition to their role as instructional objects, many dolls were made to be sold to outsiders who were interested in collecting Native American objects. These dolls are dressed in the distinctive style of the Huron of Lorette during the middle of the nineteenth century and are meant to illustrate everyday dress and activities. The garments show an extensive use of wool and cotton with metal ornamentation — resulting from European contact — while the moccasins reflect the continued preference for traditional footwear. Other items, such as the metal pail carried by the female doll and the gun, club, and axe tucked into the belt of the male doll, provide a glimpse of Huron daily life.

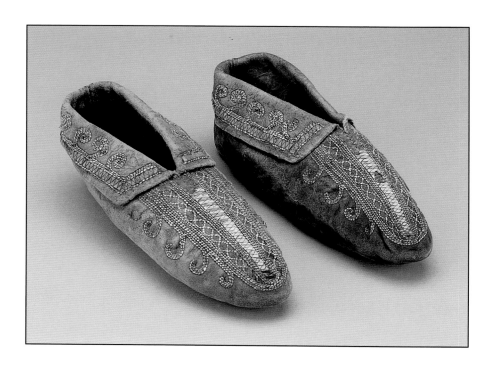

Moccasins
Huron, ca. 1850
Leather, porcupine quills
Length: 9"; Width: 3¼"; Height: 3½"
1322

Huron moccasins, like those of many other Woodlands groups, were traditionally soft soled, made from a single piece of tanned deerskin. The deerskin was cut into a predetermined form and then was stitched up the heel. The top of each moccasin and the ankle flaps are decorated with porcupine quill embroidery in curvilinear designs, a popular Woodlands motif.

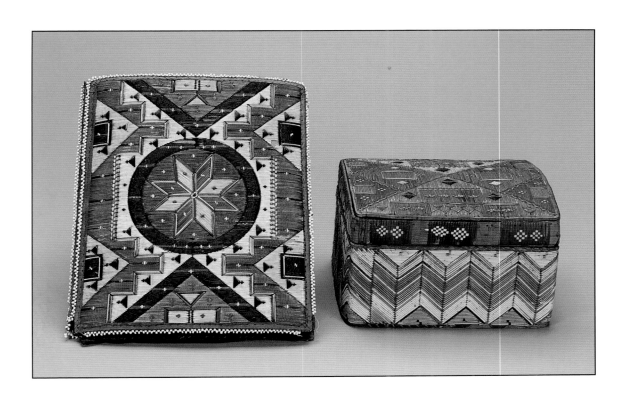

Portfolio
Micmac, ca. 1870–1880
Birch bark, porcupine quills,
 cloth lining
Length: 11"; Width: 8½"
1104

Lidded Box
Micmac, ca. 1850
Birch bark, porcupine quills
Length: 4¾"; Width: 7½";
 Height: 6¾"
1490

The Micmac have long used porcupine quills to decorate a variety of traditional items. Micmac women worked the quills in several techniques including embroidery, weaving, appliqué, and wrapping. After contact with Europeans, the artists developed a new form of quillwork: a mosaic of dyed porcupine quills on a wide assortment of birch bark objects, such as boxes, canoe models, sewing kits, and portfolios, all designed to appeal to European collecting tastes.

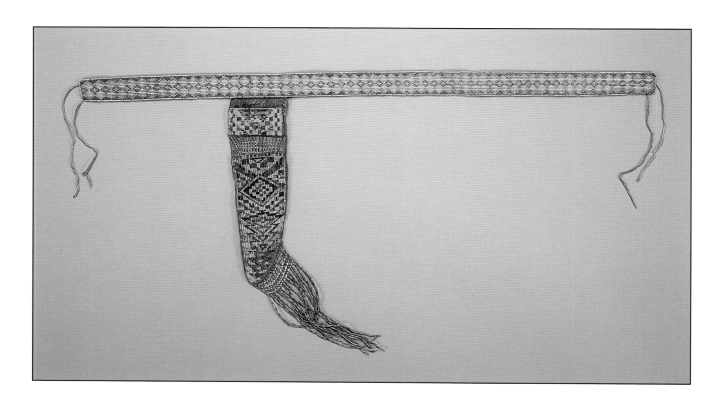

Knife Case and Belt
Cree, ca. 1850
Leather, porcupine quills, glass beads
Length: 31"; Width: 12"
87.88.14

Many Woodlands groups, including the Cree, wove and sewed porcupine quills onto objects and garments. Woven quillwork is produced on a bow loom, with the flattened quills inserted between the warp threads and then folded over and under the weft threads. This knife case and belt illustrate the fine weave resulting from this quillwork technique. The designs on woven quillwork are usually geometric and are often executed in red, yellow, and orange on a white or natural background.

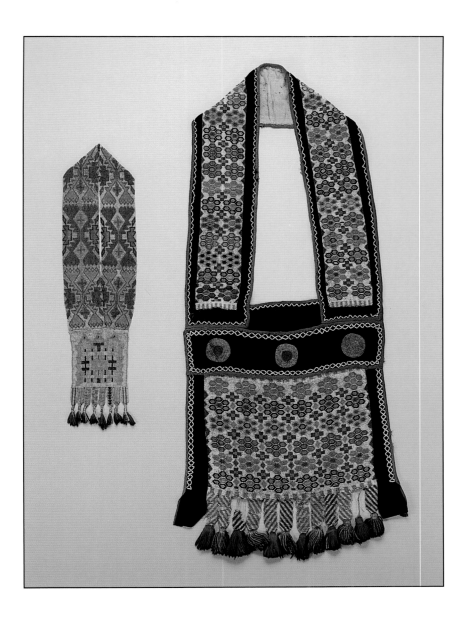

Boy's Bandolier Bag
Chippewa, ca. 1870
Glass beads, wool yarn
Length: 23½"; Width: 5¾"
1881

Bandolier Bag
Potawatomi, ca. 1870
Wool cloth, glass beads, wool yarn
Length: 39"; Width: 16"
1180

Bandolier bags were especially popular with the peoples of the western Great Lakes such as the Chippewa and Potawatomi. Although the original purpose of these bags was to carry game and ammunition, they came to be heavily decorated with beadwork. The Chippewa bag is a rare example of a little boy's bandolier bag. It is entirely loom beaded in geometric designs. As a decorative piece made for special occasions, it may or may not have ever been sewn onto a cloth pouch. The Potawatomi bag is decorated with a geometricized floral beadwork pattern that was also woven on a loom.

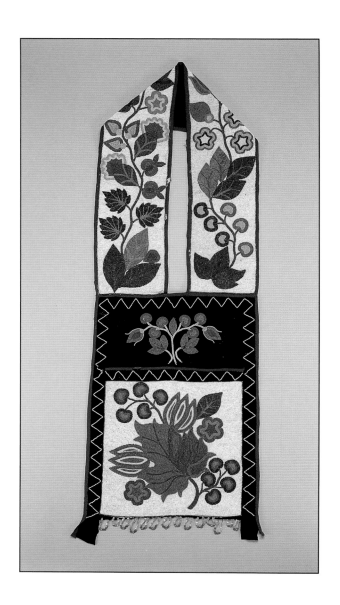

Bandolier Bag
Chippewa, ca. 1900
Wool cloth, glass beads
Length: 40"; Width: 15"
87.88.3a

By 1900 bandolier bags were considered mostly decorative, to be brought out on important occasions. Chippewa bags of the early twentieth century, such as this one, are often decorated with beadwork applied directly to the cloth in an overlay stitch rather than being woven on a loom. The large panel is beaded with an asymmetrical floral design on a solid white background. Above the large panel a second area is beaded in floral designs without a background. The strap is fully beaded, again with a floral design on a solid white background. This design includes a wild variety of abstract and stylized leaves attached to vines, with a clear emphasis on asymmetry between the elements on each side of the strap.

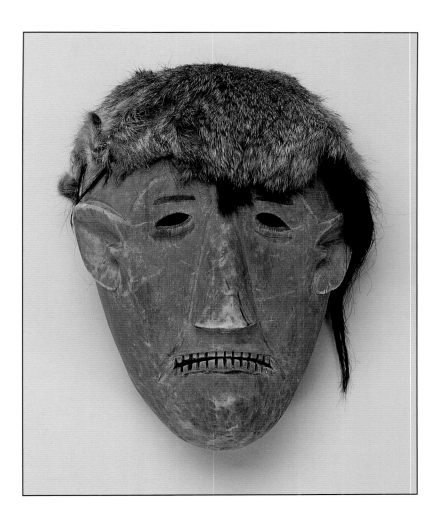

Mask
Cherokee, ca. 1850–1900
Wood, paint, hide, hair
Length: 11"; Width: 9"; Height: 5¾"
86.126.33

During the Booger Dance, the Cherokee used masks to portray outsiders. The name of the dance is probably derived from the English term "bogie" or "bogeyman," meaning a rude and uncouth person — which is how the Cherokee regarded strangers. During the festivities the masked dancers satirized the awkward movements of European dancing, while making vulgar comments and gestures. This mask is finely carved from a single piece of wood with fur and hair attached to the top of the head. The long face and straight nose are a caricature of Caucasian features, while the vacant expression gives the mask a buffoonish appearance in keeping with the humorous intent of a Booger Dance performance.

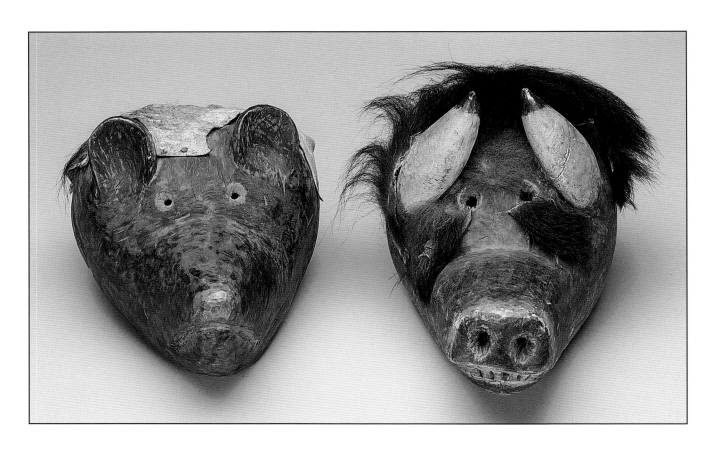

Mask
Cherokee, ca. 1850–1900
Wood, paint, hide
Length: 12½"; Width: 10"; Height: 6"
91.95.19

Mask
Cherokee, ca. 1850–1900
Wood, paint, buffalo hide
Length: 13"; Width: 8¼"; Height: 7¼"
91.95.20

Masks depicting animals, although rare, were also made by the Cherokee. The exact function of these masks is unknown; however, they may have played a role in the Booger Dance or some other event where masks were called for. These representations of a bear and a buffalo are each carefully carved from a single piece of wood, painted, and then decorated with hide and fur. The facial features carry expressions that may relate to their use in a performance.

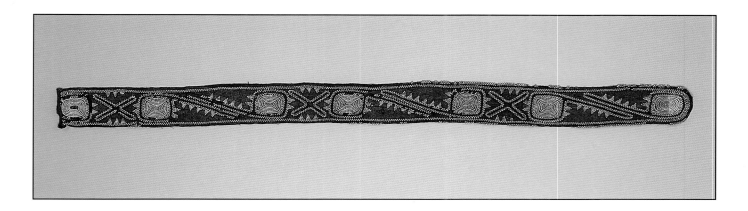

Sash
Choctaw, ca. 1850
Wool cloth, glass beads
Length: 48¾"; Width: 3"
91.95.95

Beaded belts and sashes were commonly made by the Choctaw and other tribes of the Southeastern United States. They may have also been used as straps for shoulder bags. These sashes are made from wool cloth that has been decorated with beadwork; the all-white design features a scroll motif similar to designs found on prehistoric objects from the same region.

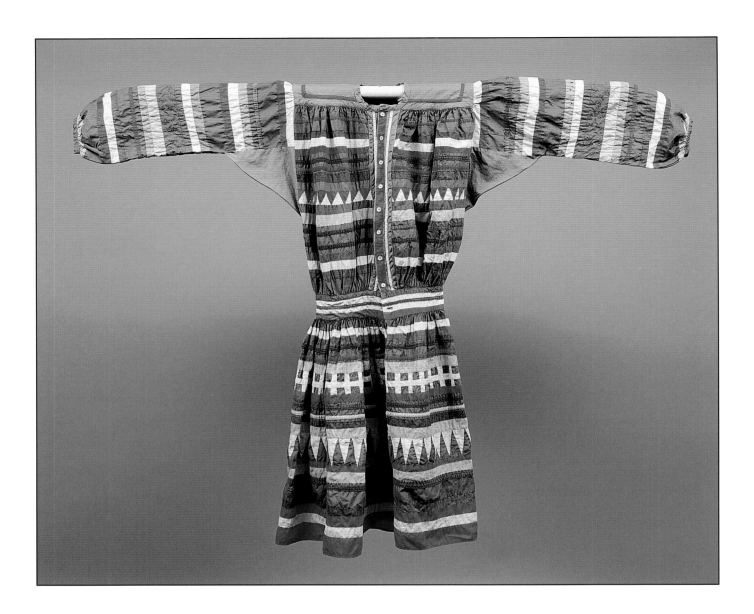

Big Shirt
Seminole, ca. 1900
Cloth
Length: 47"; Width: 59½"
1854

The Seminoles adapted a non-Native patchwork quilting technique of the nineteenth century to create these brightly colored garments. They now consider it to be one of their traditional art forms. Big shirts, as they are called, were traditionally worn by men, with the long sleeves and loose fit providing protection and comfort in the heat and humidity of the Florida swamps.

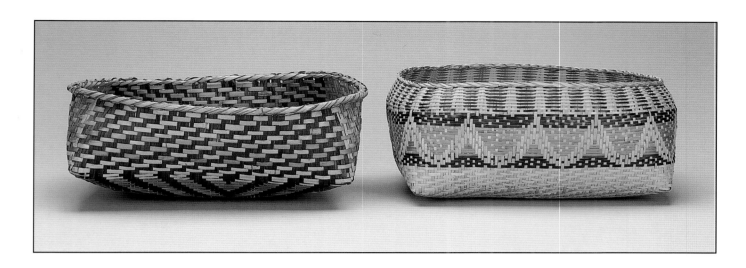

Basket
Choctaw, ca. 1920
Split cane
Height: 5¾"; Length: 14"; Width: 12¼"
684

Basket
Chitimacha, ca. 1920
Split cane
Height: 6¼"; Length: 12¾"; Width: 11"
677

Basket making is one of the traditional art forms among the tribes of the Southeastern United States. Twill plaited baskets, such as these, are usually made from split cane or oak. The cane is split into lengths and colored using either commercial dyes or vegetal material, such as walnut for black and brown and bloodroot for red and orange. The different colored splints frequently form a pattern that covers the entire surface of the basket. Chitimacha baskets are often made with finer splints and have more complex designs that incorporate both geometric and curvilinear elements.

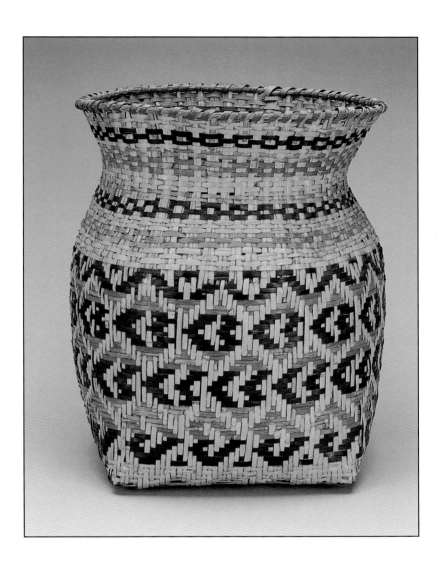

Basket
Cherokee, ca. 1920
Split cane
Height: 16"; Diameter: 12"
673

This is a typical example of the art of twill plaited Cherokee basket making.
The large jar shape with a flat bottom would have been appropriate for use
as a storage container for food or other items. A repeating geometric pattern
covers most of the outer surface of the basket.

Selected Bibliography

Coe, Ralph T. *Sacred Circles*. Kansas City, Missouri: Nelson Gallery of Art / Atkins Museum of Fine Arts, 1976.

Collins, Henry B., et al. *The Far North: 2000 Years of American Eskimo and Indian Art*. Washington, D.C.: National Gallery of Art, 1973.

Conn, Richard. *A Persistent Vision: Art of the Reservation Days*. Denver, Colorado: Denver Art Museum, 1986.

Hail, Barbara A. *Hau, Kóla!* Bristol, Rhode Island: Haffenreffer Museum of Anthropology, 1980.

Jacknis, Ira, Julian Lang, and Malcolm Margolin. *Indian Regalia of Northwest California*. Berkeley, California: Phoebe Apperson Hearst Museum of Anthropology, 1994.

Jonaitis, Aldona. *Art of the Northern Tlingit*. Seattle, Washington: University of Washington Press, 1986.

Linn, Natalie. *The Plateau Bag: A Tradition in Native American Weaving*. Pittsburg, Kansas: Johnson County Community College, 1994.

Mercer, Bill. *Singing the Clay: Pueblo Pottery of the Southwest Yesterday and Today*. Cincinnati, Ohio: Cincinnati Art Museum, 1995.

Moser, Christopher L. *Native American Basketry of Central California*. Riverside, California: Riverside Museum Press, 1986.

Nunley, John W. and Janet Berlo. "Native North American Art," *The Saint Louis Art Museum Bulletin*, vol. xxi, no. 1. St. Louis, Missouri: St. Louis Art Museum, 1991.

Portland Art Museum. *Portland Art Museum Selected Works*. Portland, Oregon: Portland Art Museum, 1996.

Schlick, Mary Dodds. *Columbia River Basketry: Gift of the Ancestors, Gift of the Earth*. Seattle, Washington: University of Washington Press, 1994.

Turnbaugh, Sarah Peabody and William A. Turnbaugh. *Indian Baskets*. West Chester, Pennsylvania: Schiffer Publishing Ltd., 1986.

Vaughan, Thomas and Bill Holm. *Soft Gold: The Fur Trade & Cultural Exchange on the Northwest Coast of America*. Portland, Oregon: Oregon Historical Society Press, 1982.

Vincent, Gilbert T. *Masterpieces of American Indian Art from the Eugene and Clare Thaw Collection*. New York, New York: Harry N. Abrams, Inc., 1995.

Wade, Edwin L., Carol Haralson, and Rennard Strickland. *As in a Vision: Masterworks of American Indian Art*. Norman, Oklahoma: University of Oklahoma Press and the Philbrook Art Center, 1983.

Wade, Edwin L., ed. *The Arts of the North American Indian: Native Traditions in Evolution*. New York, New York: Hudson Hills Press, 1986.

Whiteford, Andrew Hunter. *Southwestern Indian Baskets: Their History and Their Makers*. Santa Fe, New Mexico: School of American Research Press, 1988.

Wooley, David, ed. *Eye of the Angel: Selections from the Derby Collection*. Northampton, Massachusetts: White Star Press, 1990.

Wright, Robin K., ed. *A Time of Gathering: Native Heritage in Washington State*. Seattle, Washington: University of Washington Press and the Thomas Burke Memorial Washington State Museum, 1991.